12/07

D0114266

the best graffiti from around the world

Graffiti Planet

compiled and introduced by KET

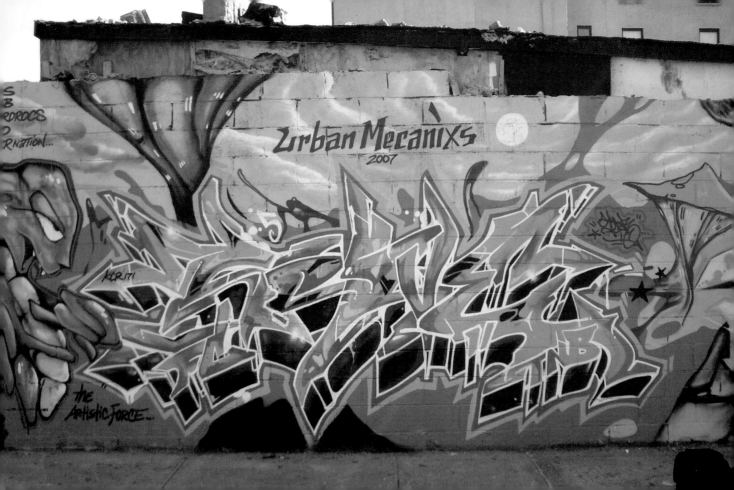

the best graffiti from around the world

Graffiti Planet

compiled and introduced by KET

Michael O'Mara Books Limited

First published in Great Britain in 2007 by
Michael O'Mara Books Limited
9 Lion Yard
Tremadoc Road
London SW4 7NQ

Copyright © KET 2007

ISBN: 978-1-84317-280-2

1 3 5 7 9 10 8 6 4 2

www.mombooks.com

Page 2 image: SERVE, Bronx, New York, USA
Endpapers: Detail of COPE2, T-KID 170, CEE, and MYRE, Barcelona, Spain (front);
CMP ONE, Copenhagen, Denmark (back)

Designed by Envy Design

Printed and bound in Malaysia by Tien Wah Press Pte Ltd

Acknowledgements

Special thanks to Susan Farrell at Art Crimes, Danny Good, Melisa Rivière of B-Girl Be, WANE COD crew, Tracey Wares, MYRE MAC crew, ZEKIS, DJ CEET, Raul Gamboa, POWER Clockworks crew, SIGN, CHINO BYI, KAMI TFP, and SMART for the connects and help.

Rest in peace: SANE XTC, PG 3, REC 127, ORO, MACHO, and Genesis Lampkin.

Introduction

To many people around the world graffiti is an eyesore, mainly because it is alien to them, foreign, unknown, and a chaotic obstruction to everyday organized living. The ordinary citizen's disconnection to the writing on the walls has allowed for anti-graffiti laws to be created by politicians with little fuss, and usually with the public's support. In turn, the creators of the writings have become outlaws, simply because of the criminalization of the public act of getting up their names and messages.

What becomes of a criminal artist? Many are prosecuted and have even gone to jail, as cities get cleaner in order to attract big retailers and big money. Others retire and go on to work in the arts, designing clothes, ad campaigns, or selling paintings in galleries. Yet another set of artists continue to paint in the streets and tunnels, disregarding the laws designed to jail them. The impulse to paint and to communicate is too great for them to stop simply because their cities forbid it.

This book features the best work of the virtuosos who still paint the streets and trains for the sake of art, for freedom of expression, and sometimes simply just for kicks. *Graffiti Planet* showcases the paintings of some of the people that I have met on my travels around the world, and others I have not met but who are at the top of their game in their own countries.

A funny thing happened to this art movement (and it is an art movement, whether legal or not), spawned by the kids from New York City and Philadelphia. It travelled around the world, influenced youth everywhere and brought cities to life with art and expression and rebellion. It made the local graffiti writer a globetrotting traveller ready and willing to go wherever he or she could get away with painting in public, in order to share their art for free. *Graffiti Planet* features travellers such as ZEKIS, KNOW, ATOME, SMART, GHOST, OS GEMEOS, and others who go where the action is.

Long live the writers! Abolish the antiquated anti-graffiti laws!

In exile,
KET

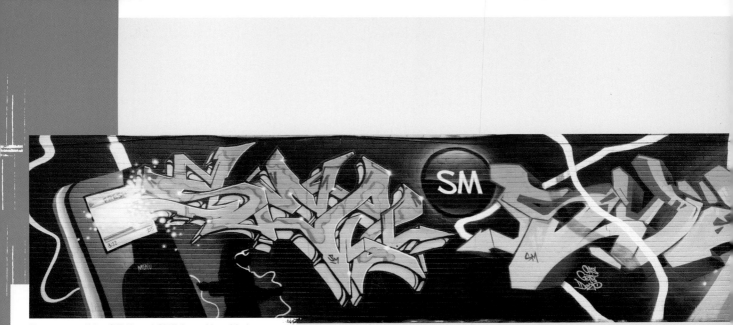

iBurners wall by SEW and SYE from New York,
and BASE, Philadelphia, Pennsylvania, USA

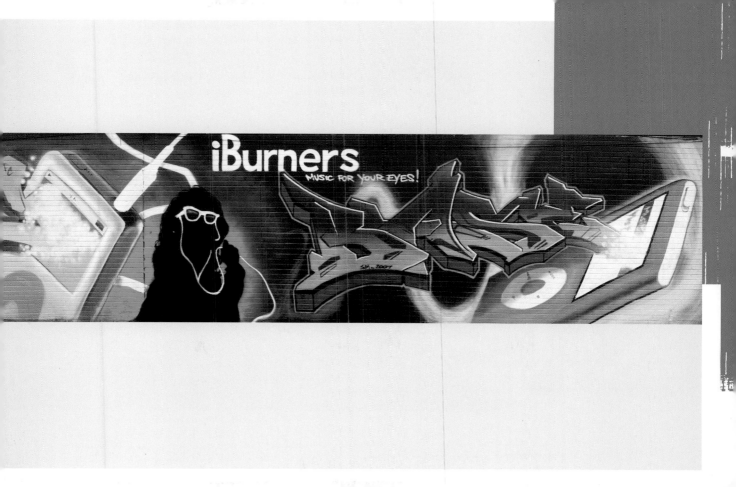

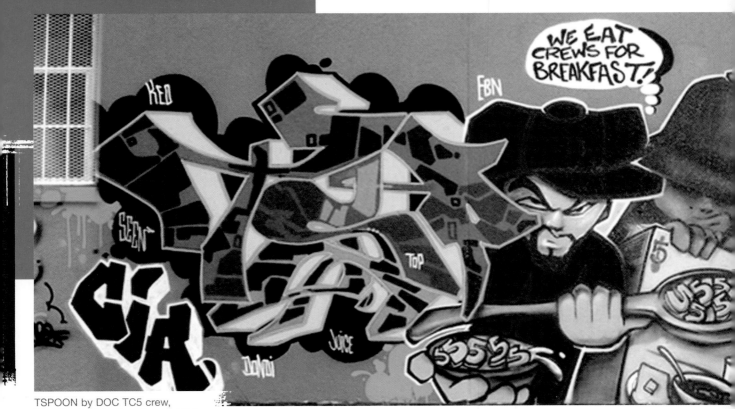

TSPOON by DOC TC5 crew,
New Brunswick, New Jersey, USA

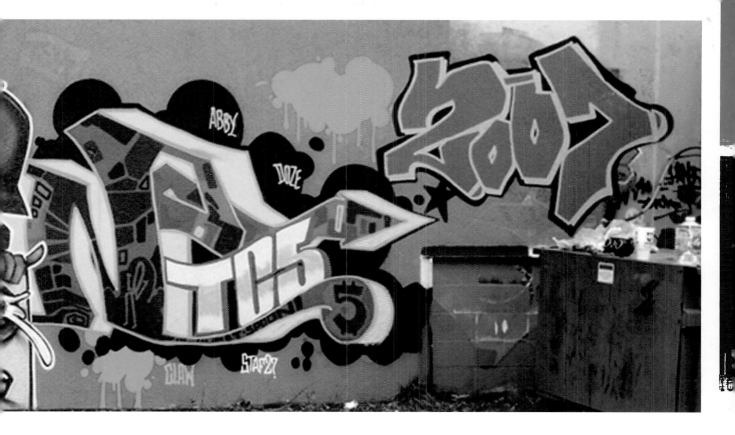

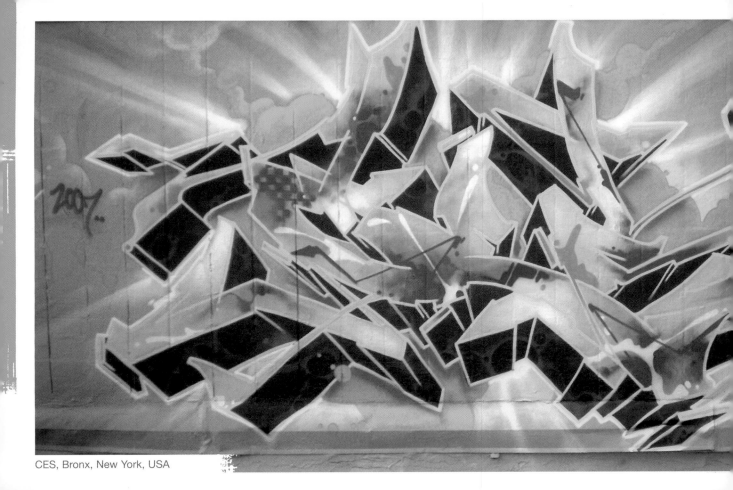

CES, Bronx, New York, USA

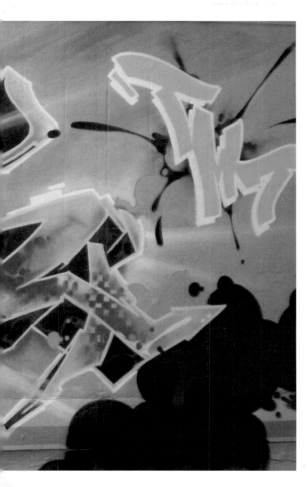

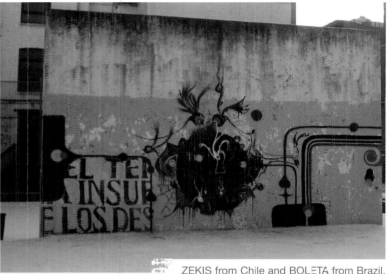

ZEKIS from Chile and BOLETA from Brazil,
Bronx, New York, USA

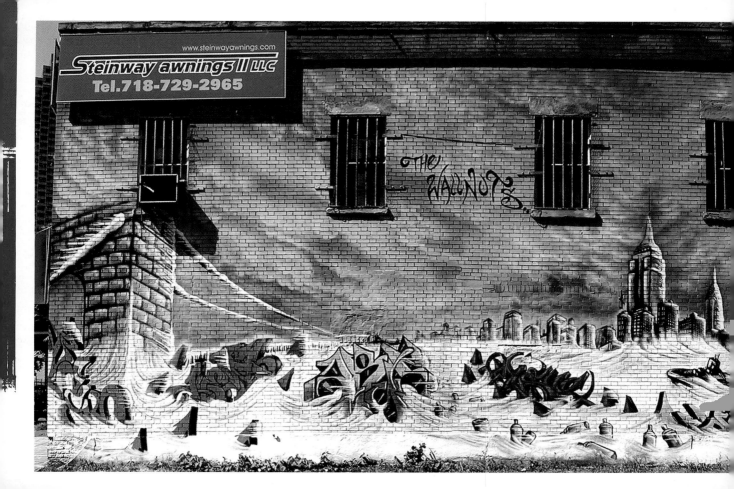

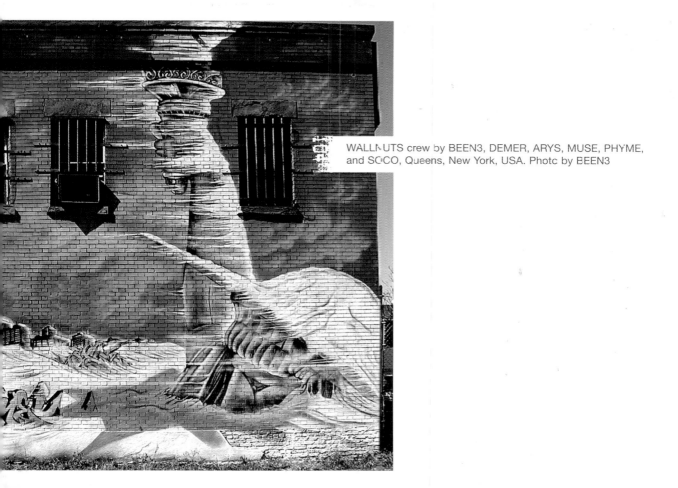

WALLNUTS crew by BEEN3, DEMER, ARYS, MUSE, PHYME, and SOCO, Queens, New York, USA. Photo by BEEN3

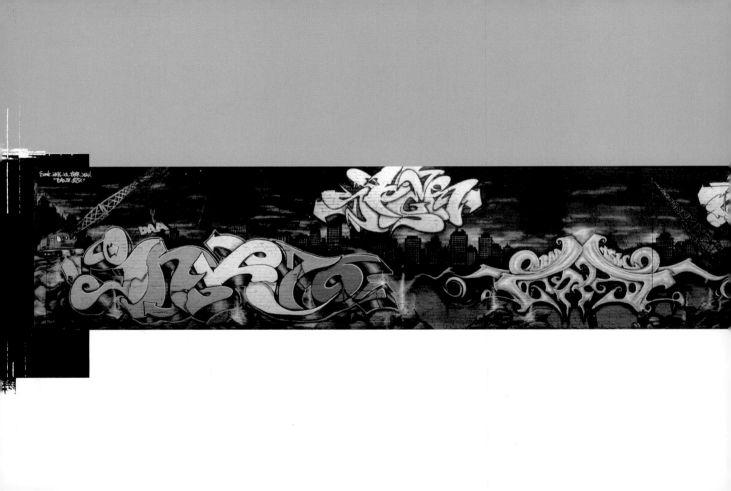

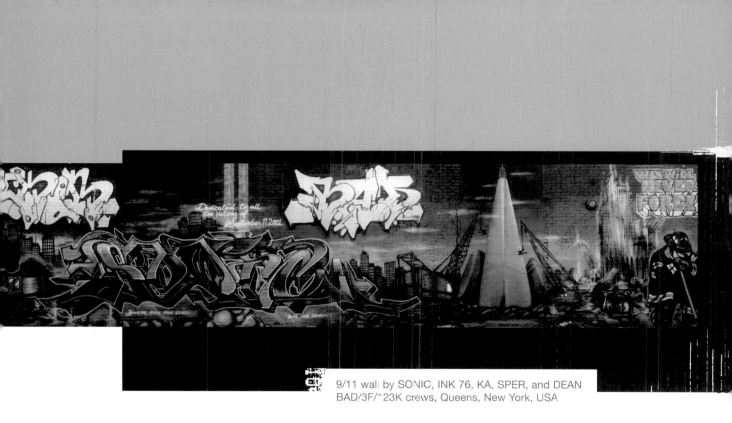

9/11 wall by SONIC, INK 76, KA, SPER, and DEAN
BAD/3F/123K crews, Queens, New York, USA

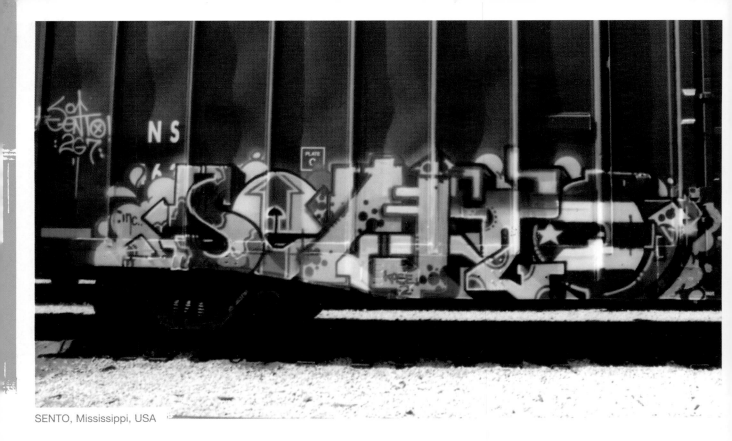

SENTO, Mississippi, USA

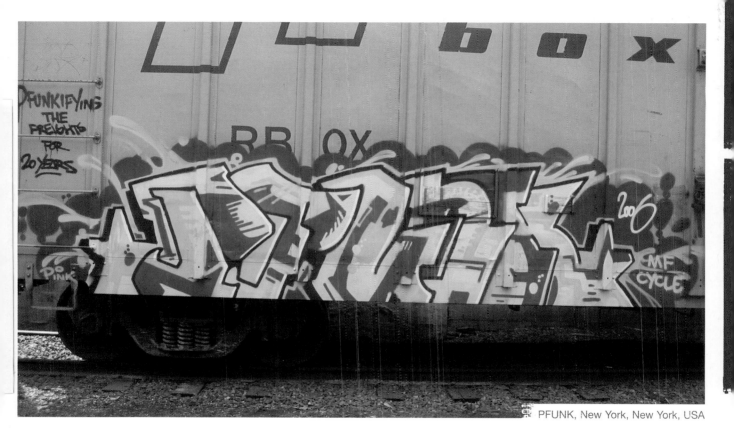

PFUNK, New York, New York, USA

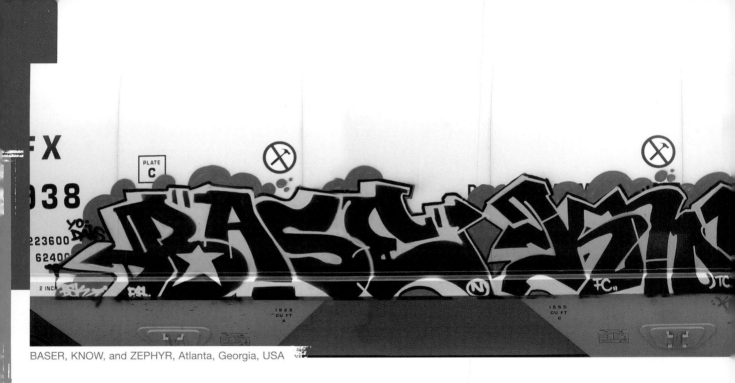

BASER, KNOW, and ZEPHYR, Atlanta, Georgia, USA

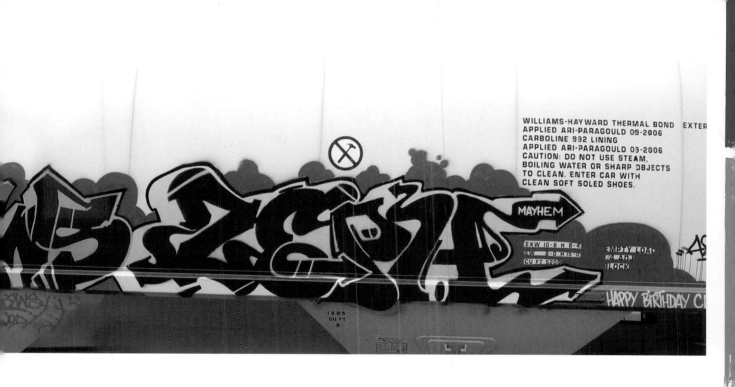

WILLIAMS-HAYWARD THERMAL BOND EXTER
APPLIED ARI-PARAGOULD 09-2006
CARBOLINE 992 LINING
APPLIED ARI-PARAGOULD 03-2006
CAUTION: DO NOT USE STEAM,
BOILING WATER OR SHARP OBJECTS
TO CLEAN. ENTER CAR WITH
CLEAN SOFT SOLED SHOES.

MAYHE.M

EXW 10-8 H 8-4 EMPTY LOAD
IEW 8-0 H15-0 /4 A.D.
CU FT 5200 BLOCK

1825
CU FT
B

HAPPY BIRTHDAY C

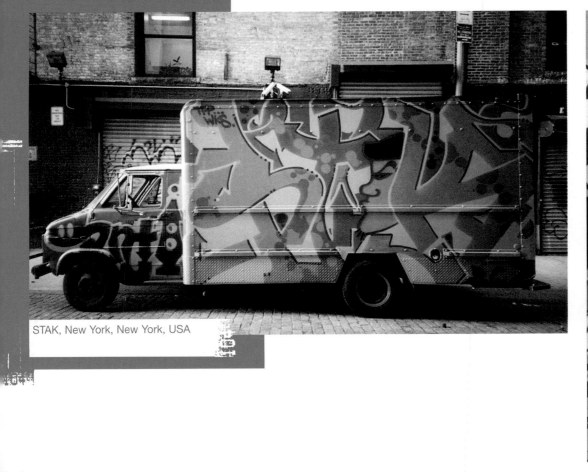

STAK, New York, New York, USA

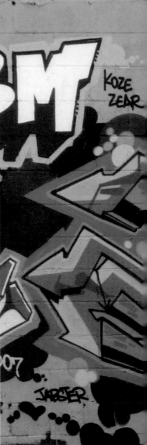

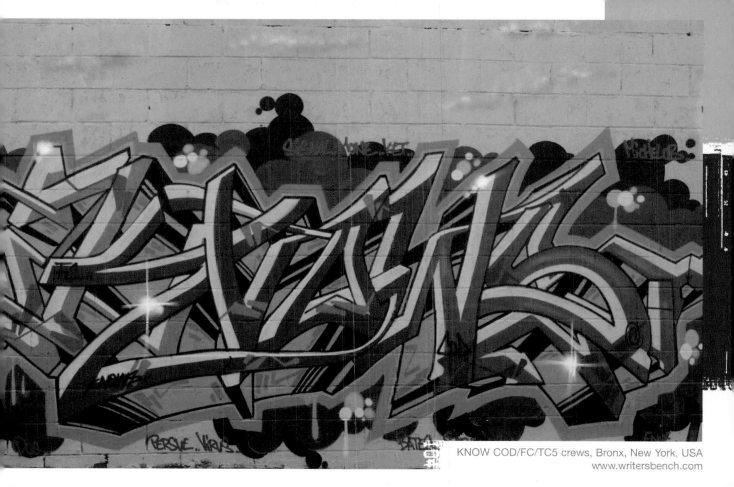

KNOW COD/FC/TC5 crews, Bronx, New York, USA
www.writersbench.com

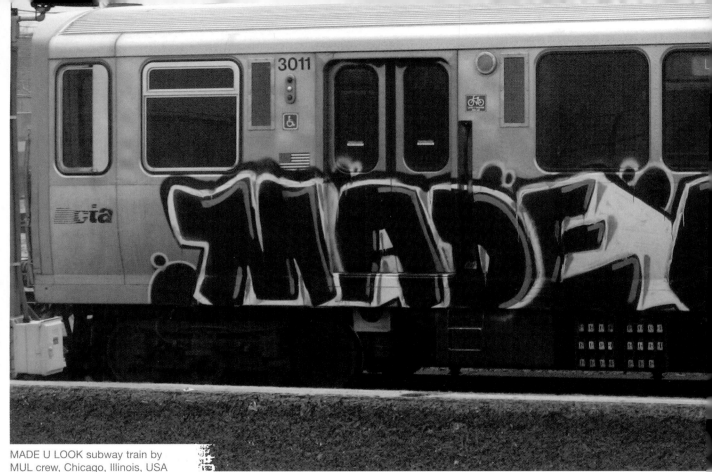

MADE U LOOK subway train by
MUL crew, Chicago, Illinois, USA

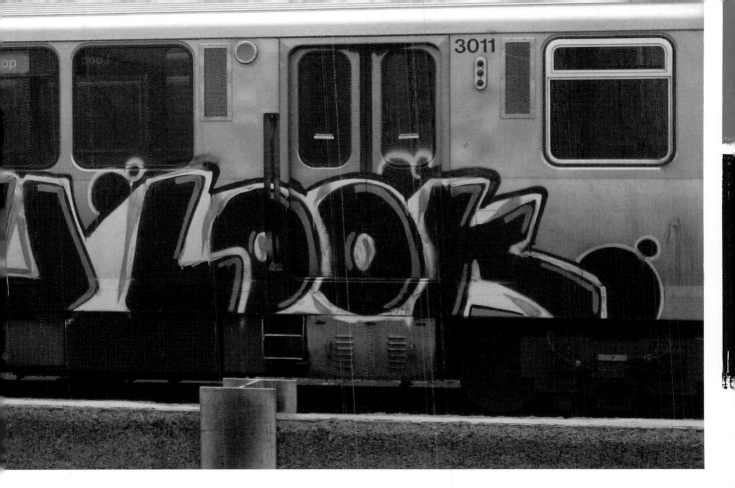

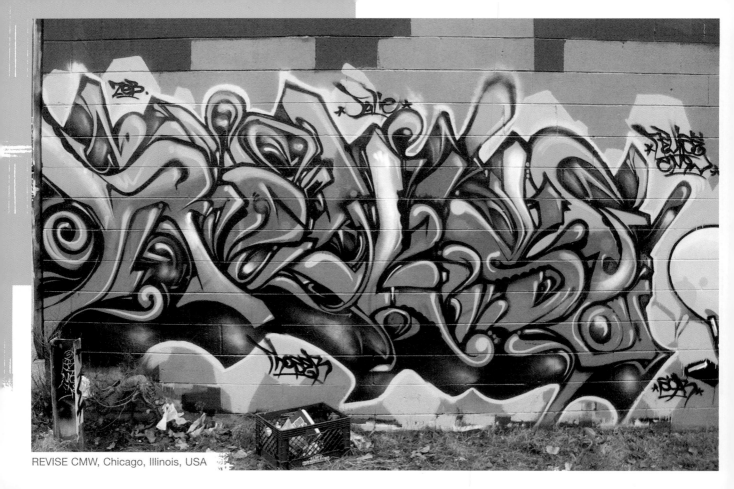

REVISE CMW, Chicago, Illinois, USA

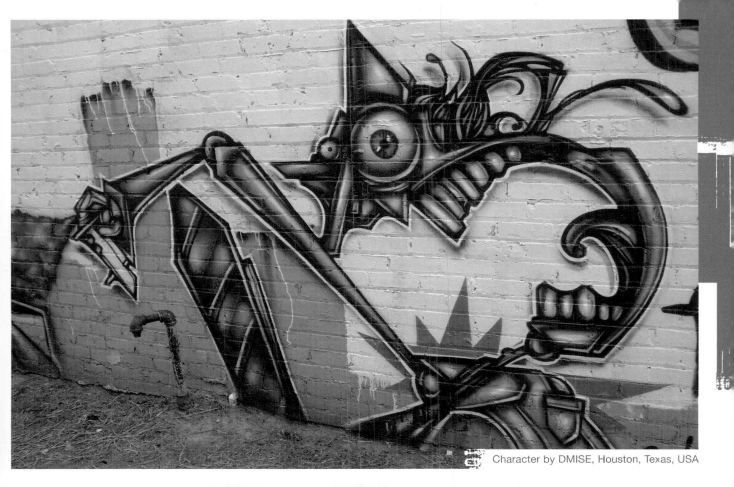

Character by DMISE, Houston, Texas, USA

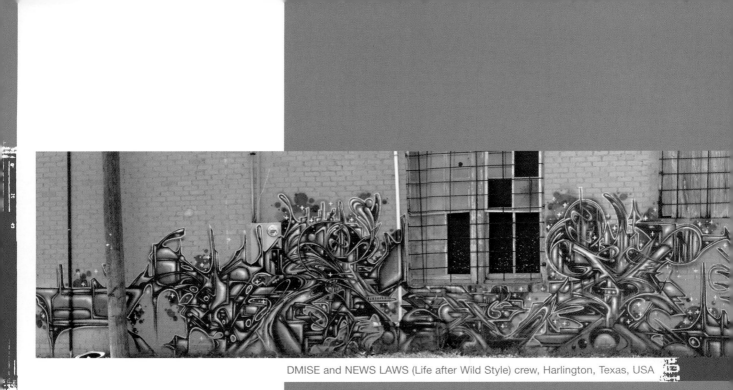

DMISE and NEWS LAWS (Life after Wild Style) crew, Harlington, Texas, USA

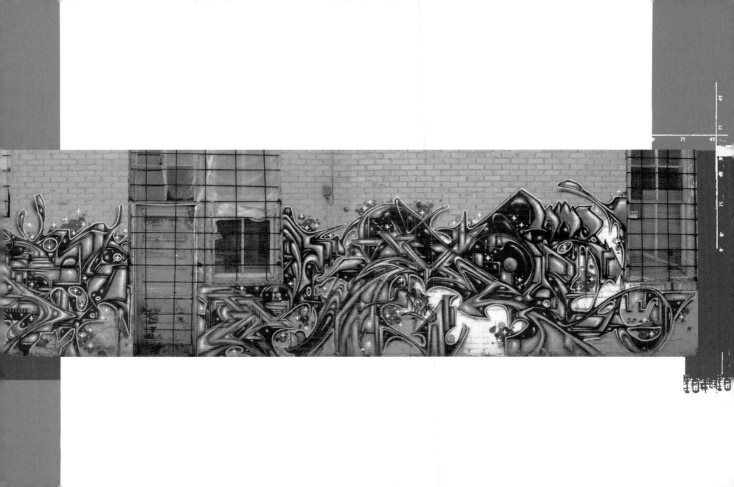

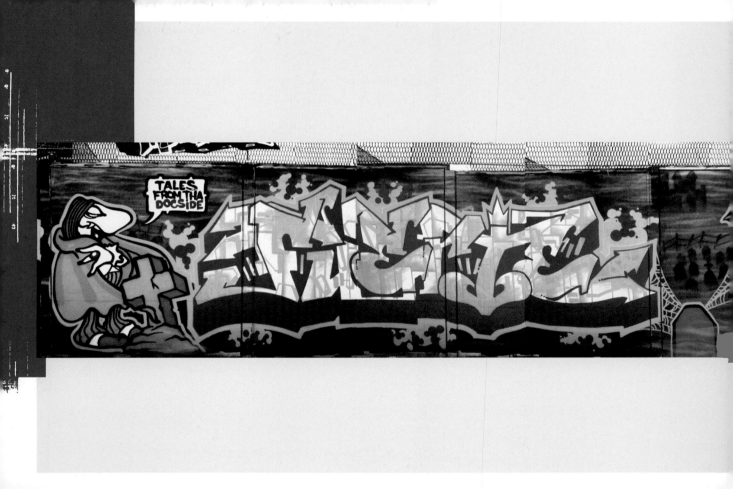

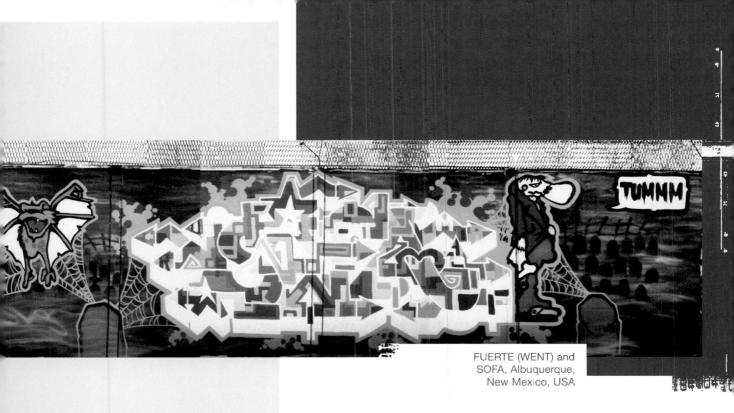

FUERTE (WENT) and
SOFA, Albuquerque,
New Mexico, USA

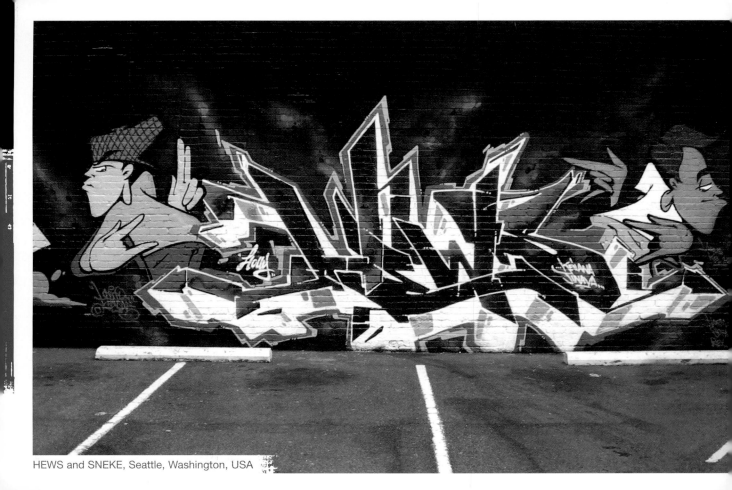

HEWS and SNEKE, Seattle, Washington, USA

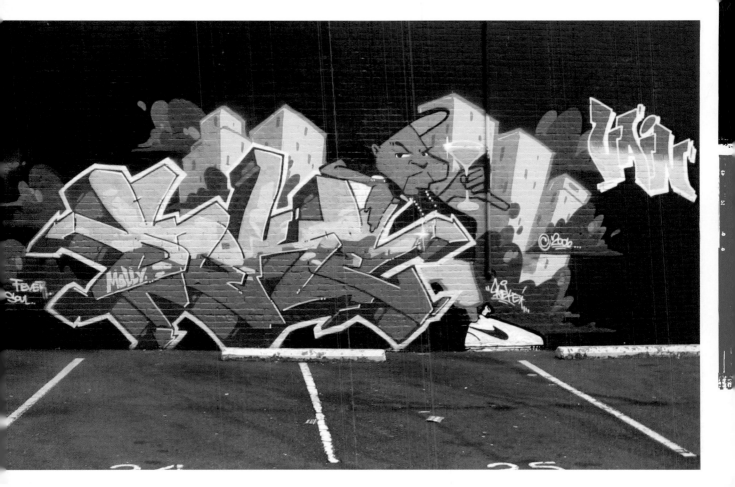

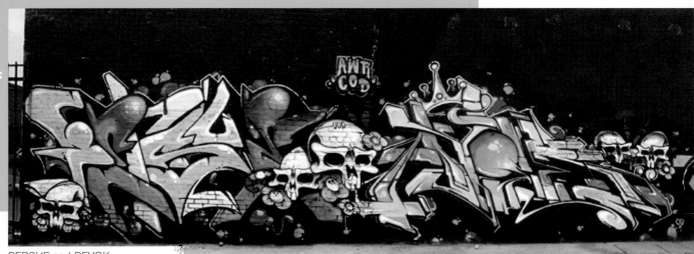

PERSUE and REVOK,
San Diego, California, USA

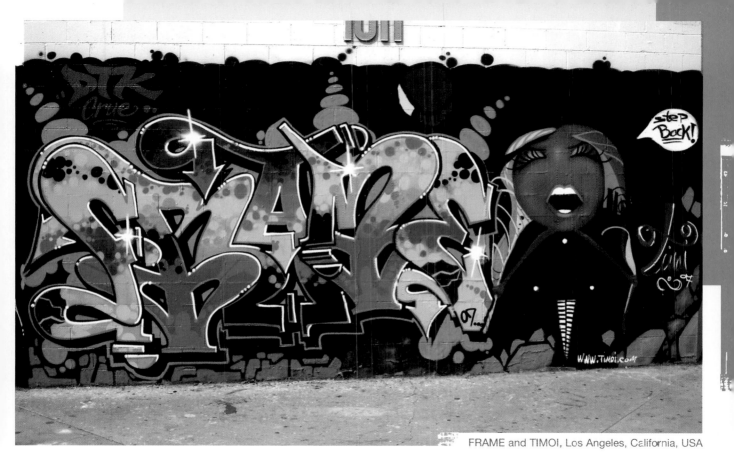

FRAME and TIMOI, Los Angeles, California, USA

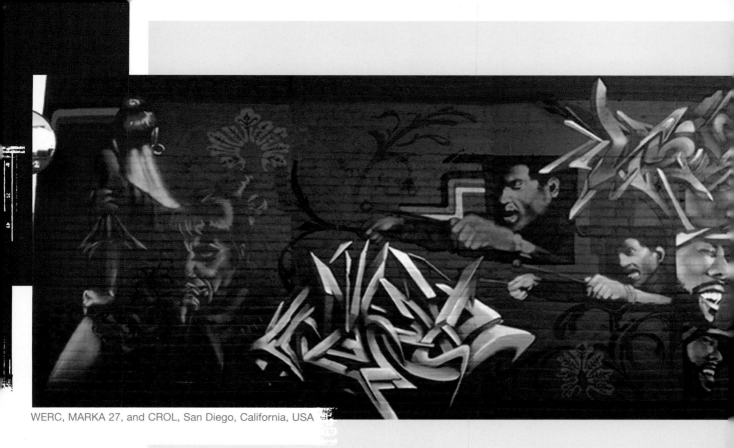

WERC, MARKA 27, and CROL, San Diego, California, USA

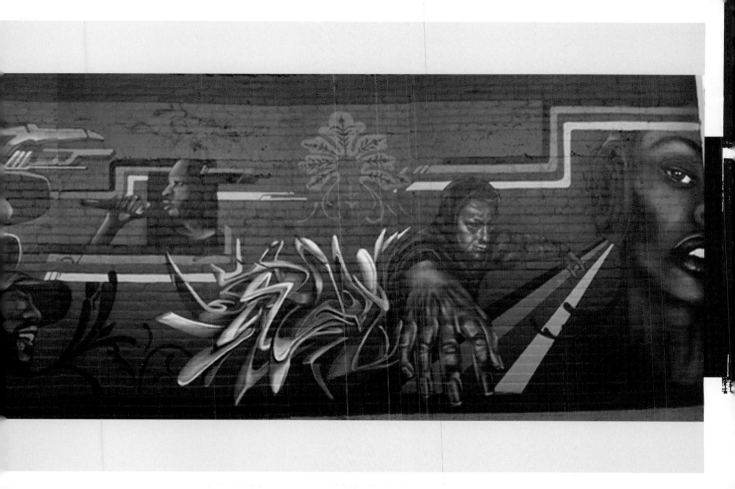

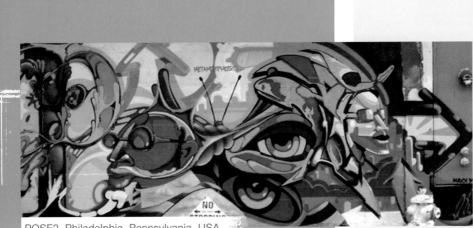

POSE2, Philadelphia, Pennsylvania, USA

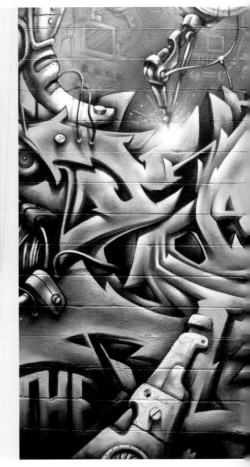

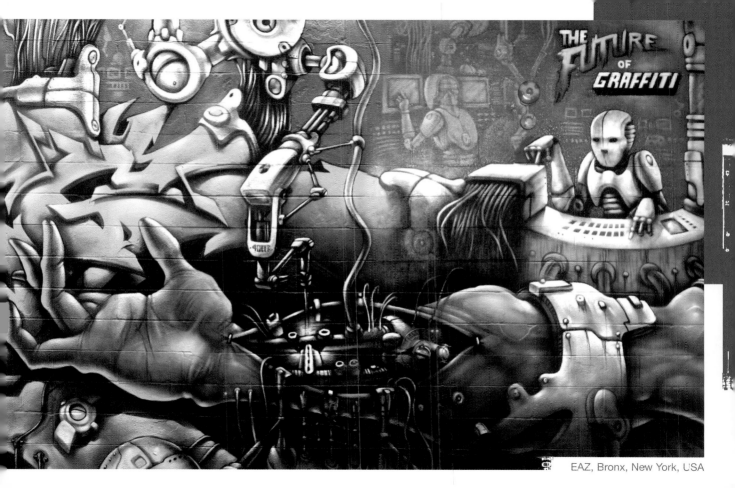

THE **Future** OF **GRAFFITI**

EAZ, Bronx, New York, USA

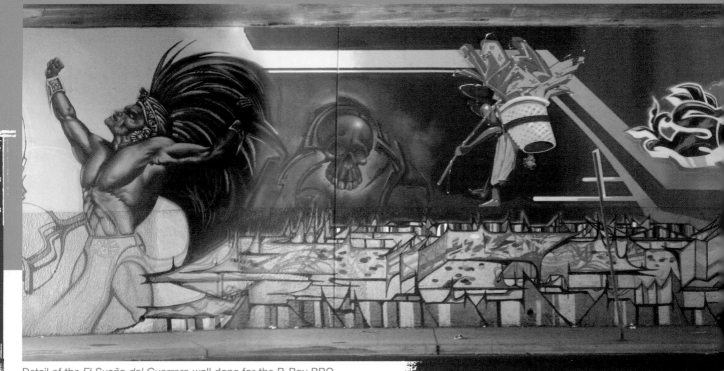

Detail of the *El Sueño del Guerrero* wall done for the B-Boy BBQ West Coast, featuring the work of over twenty artists including KOFIE, WERC, VYAL, MAN ONE, SHERM, CROL, VULCAN, OG ABEL, POSE2, CHOR BOOGIE, DASE, and SYE, Chicano Park, San Diego, California, USA

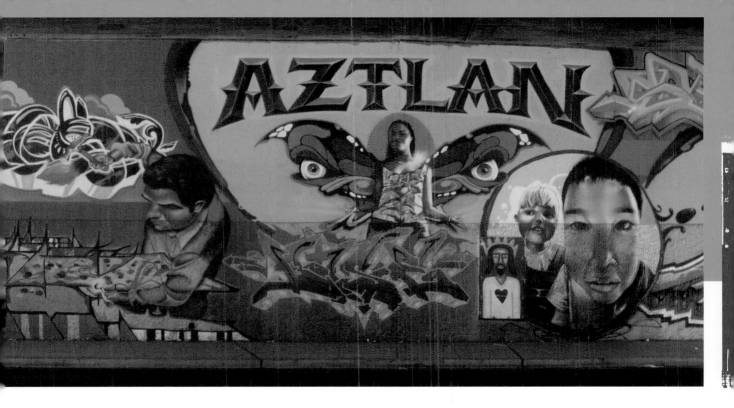

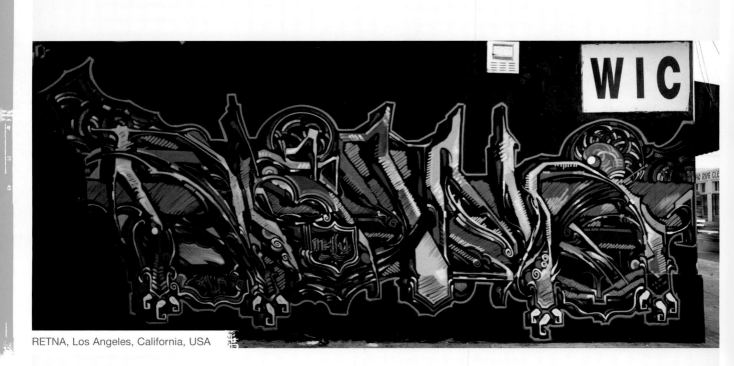

RETNA, Los Angeles, California, USA

WIC

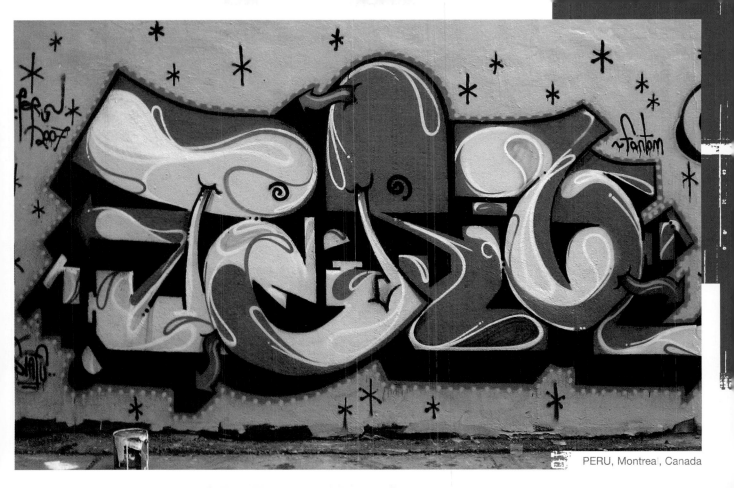

PERU, Montreal, Canada

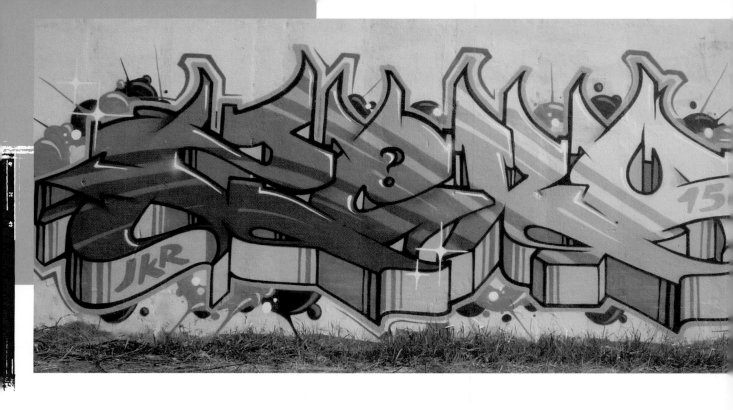

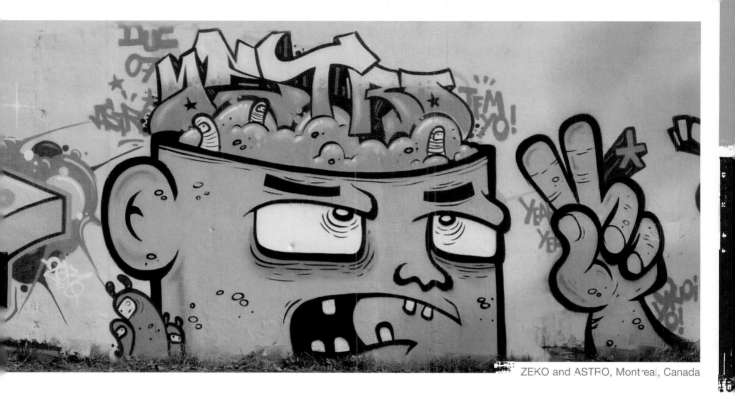

ZEKO and ASTRO, Montreal, Canada

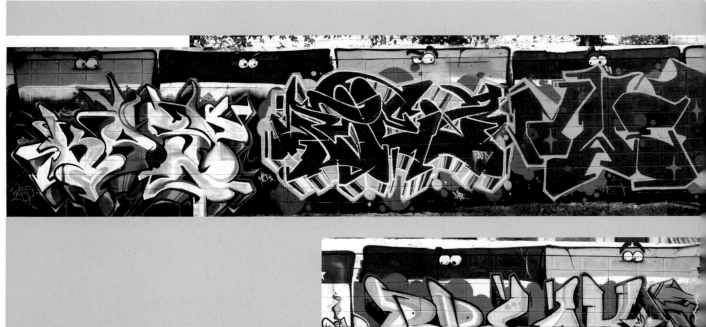

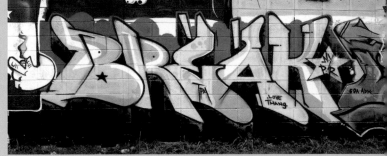

KASP, BEZ, DWEK, PUN18, BREAK,
SEL, DEFY, and XBN, Trujillo
Alto, Puerto Rico

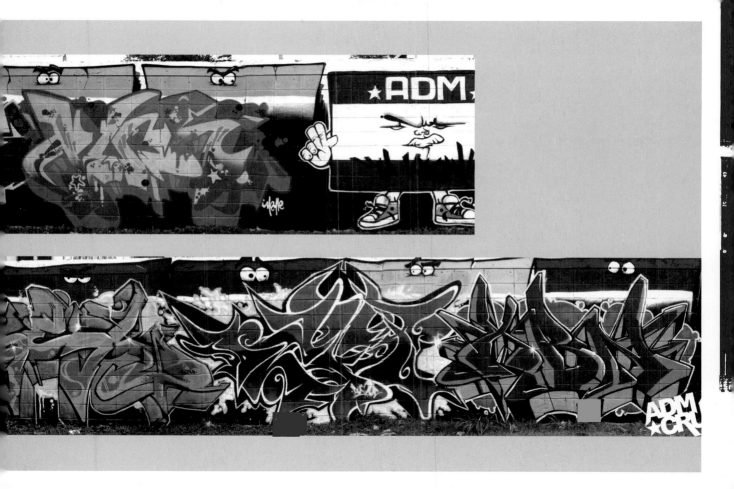

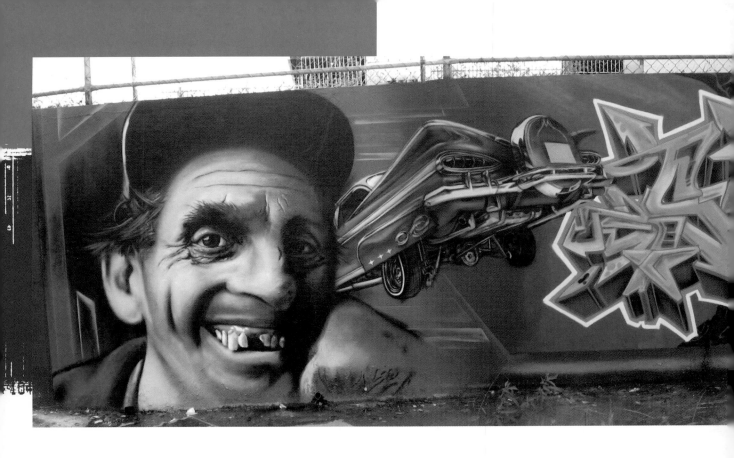

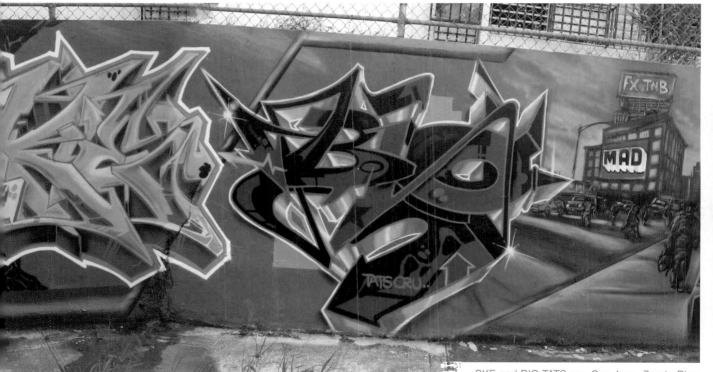

SKE and BIC TATS cru, San Juan, Puerto Rico

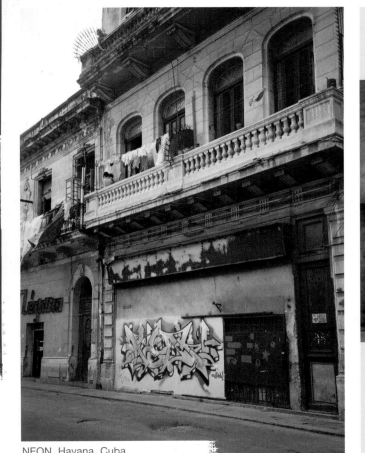

NEON, Havana, Cuba

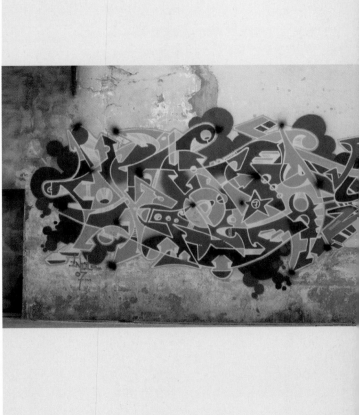

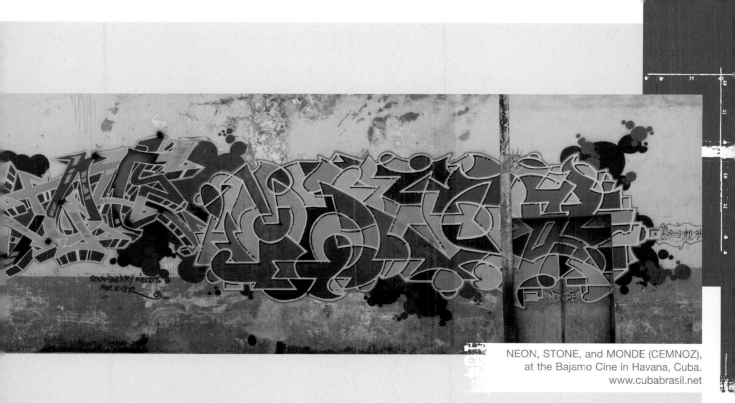

NEON, STONE, and MONDE (CEMNOZ),
at the Bajamo Cine in Havana, Cuba.
www.cubabrasil.net

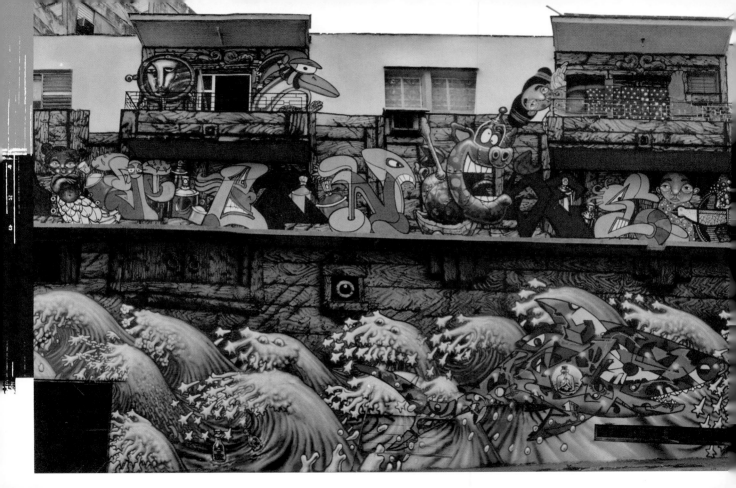

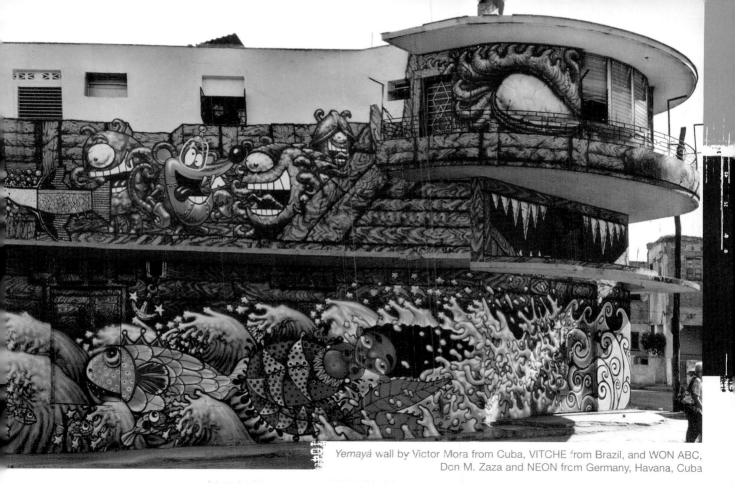

Yemayá wall by Victor Mora from Cuba, VITCHE from Brazil, and WON ABC, Don M. Zaza and NEON from Germany, Havana, Cuba

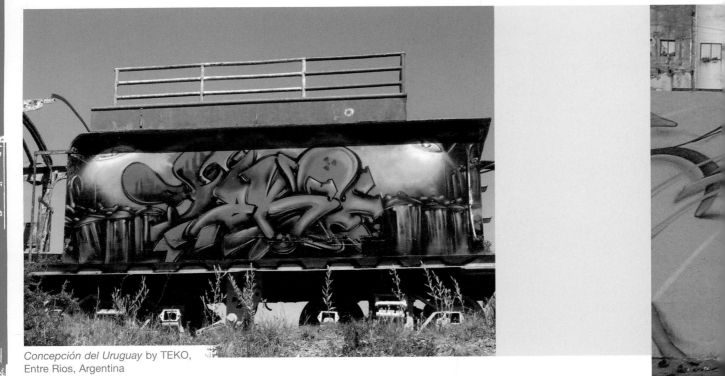

Concepción del Uruguay by TEKO,
Entre Rios, Argentina

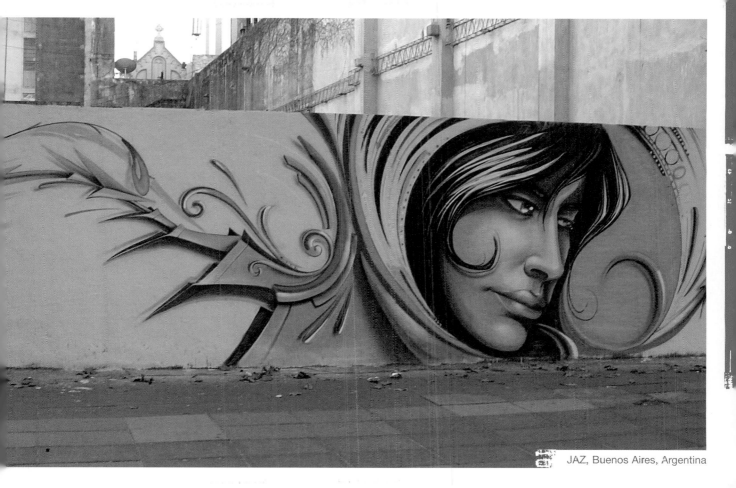

JAZ, Buenos Aires, Argentina

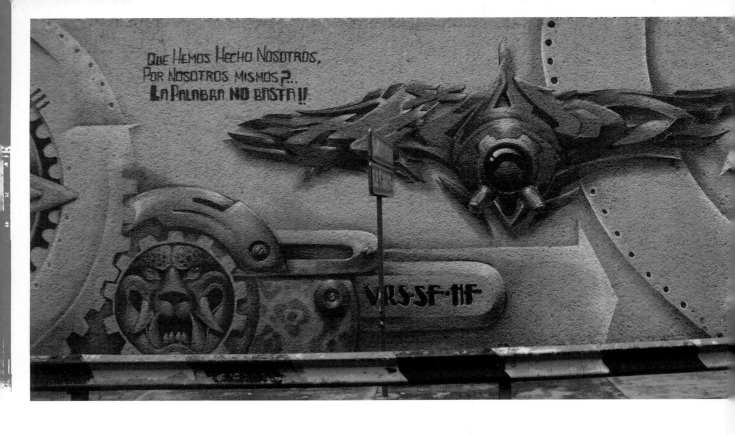

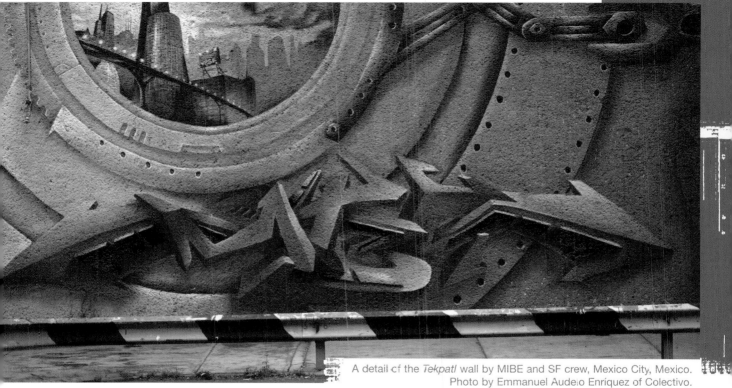

A detail of the *Tekpatl* wall by MIBE and SF crew, Mexico City, Mexico.
Photo by Emmanuel Audelo Enríquez of Colectivo.
www.graffitiarte.org

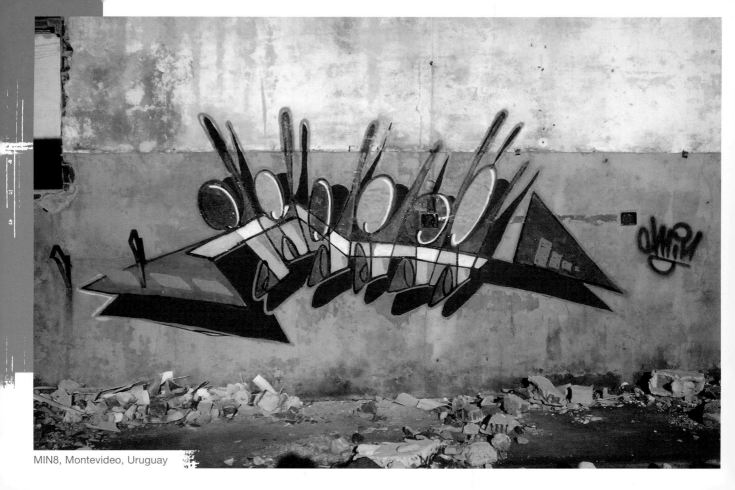

MIN8, Montevideo, Uruguay

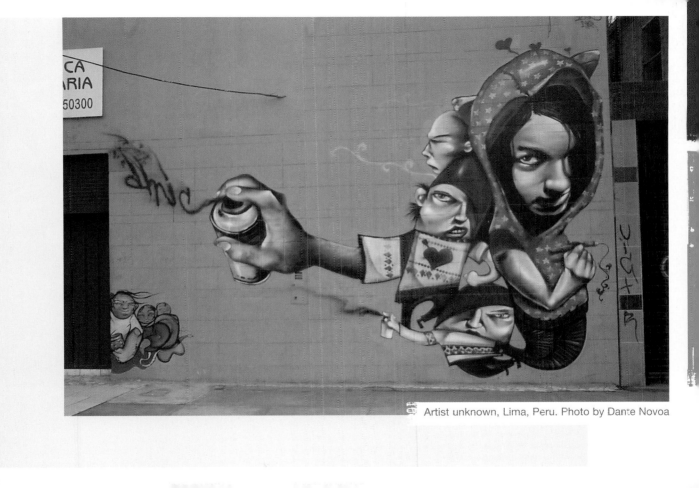

Artist unknown, Lima, Peru. Photo by Dante Novoa

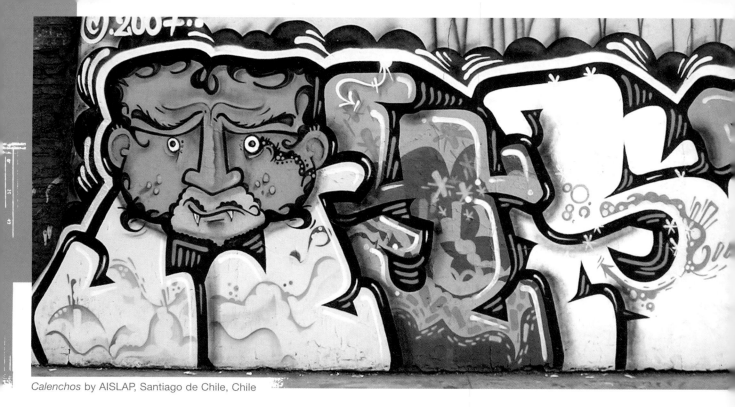

Calenchos by AISLAP, Santiago de Chile, Chile

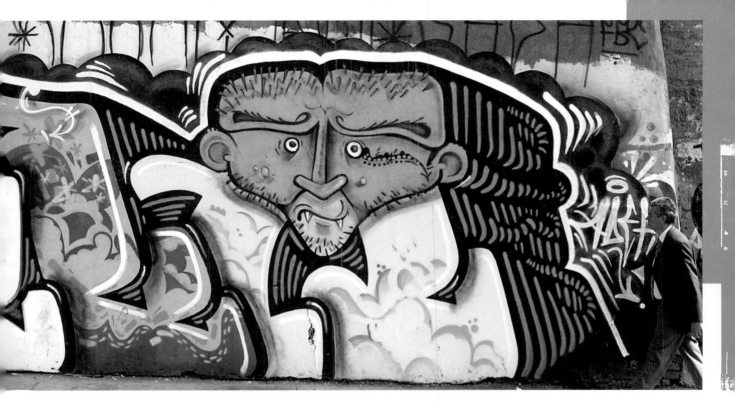

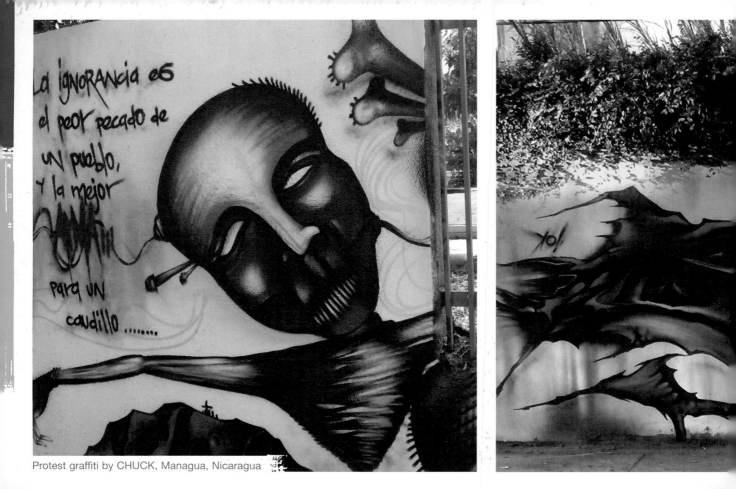

La ignorancia es el peor pecado de un pueblo, y la mejor para un caudillo

Protest graffiti by CHUCK, Managua, Nicaragua

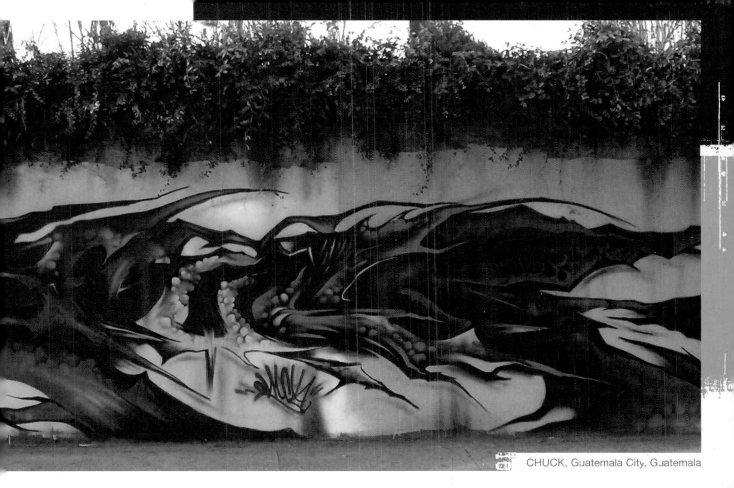

CHUCK, Guatemala City, Guatemala

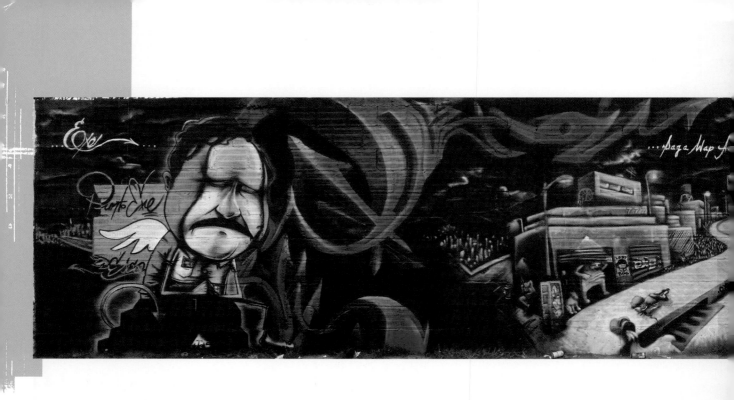

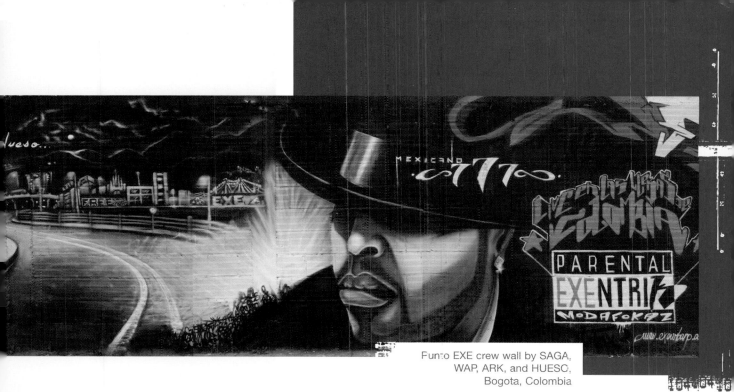

Funto EXE crew wall by SAGA, WAP, ARK, and HUESO, Bogota, Colombia

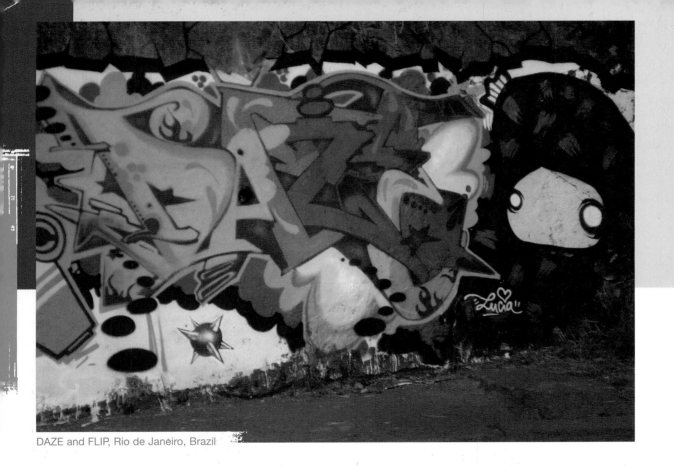

DAZE and FLIP, Rio de Janeiro, Brazil

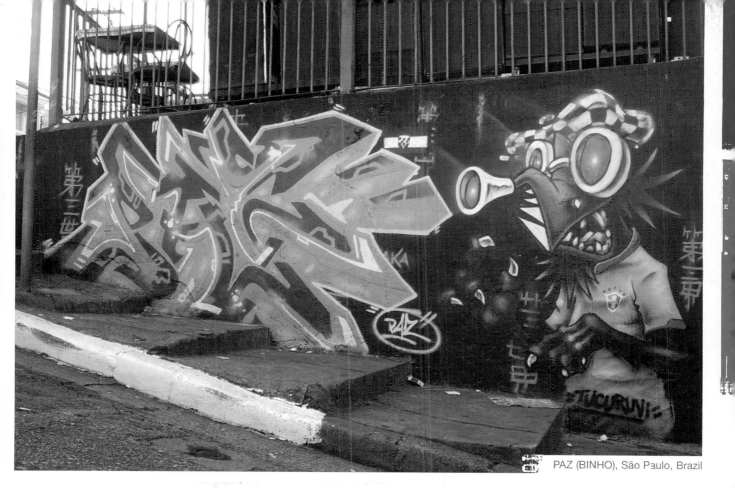

PAZ (BINHO), São Paulo, Brazil

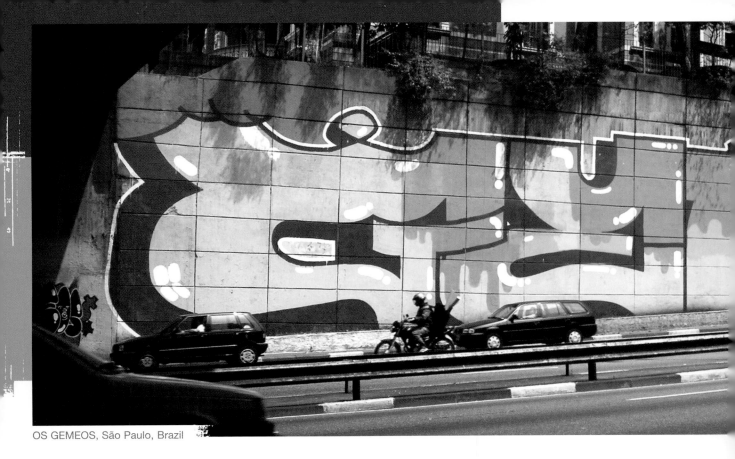

OS GEMEOS, São Paulo, Brazil

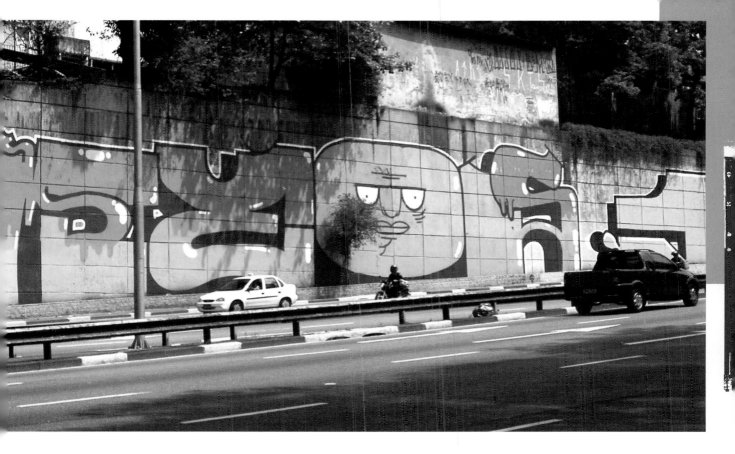

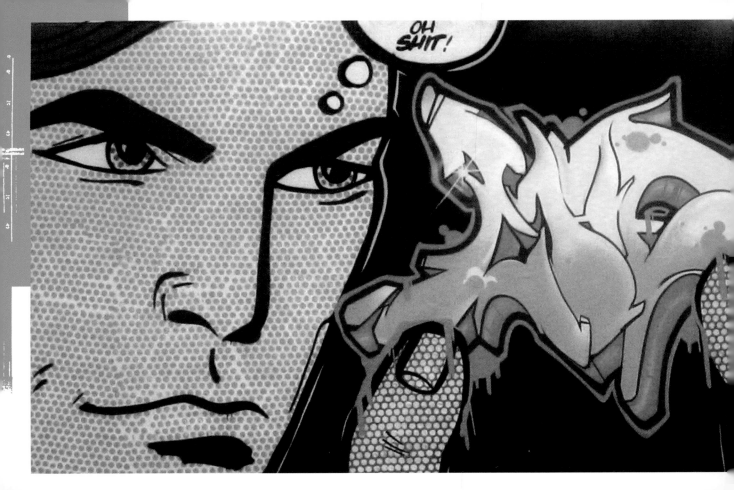

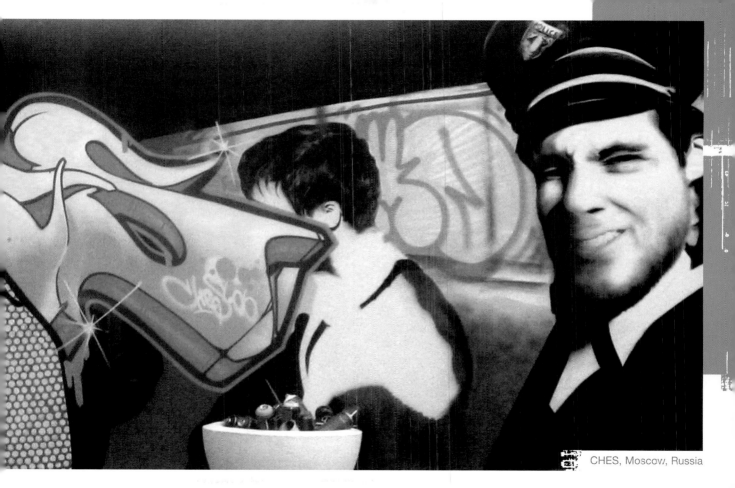

CHES, Moscow, Russia

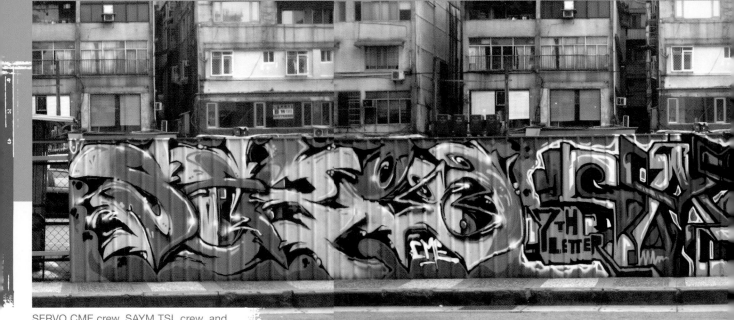

SERVO CME crew, SAYM TSL crew, and
ASESR CME/NWK crews, Taipei, Taiwan

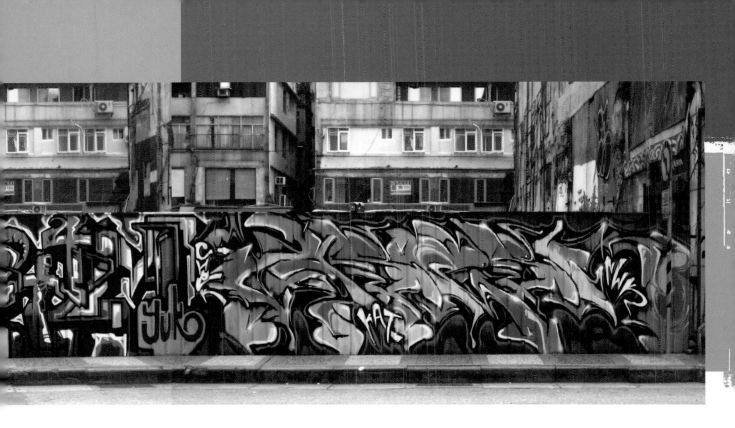

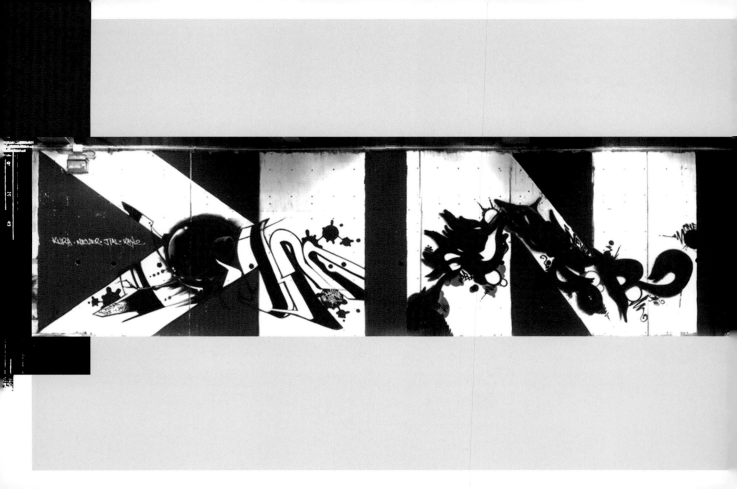

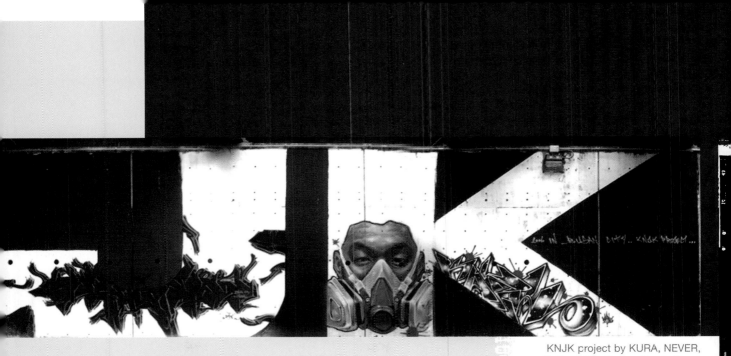

KNJK project by KURA, NEVER, JILAL, KAY2, Busan, South Korea

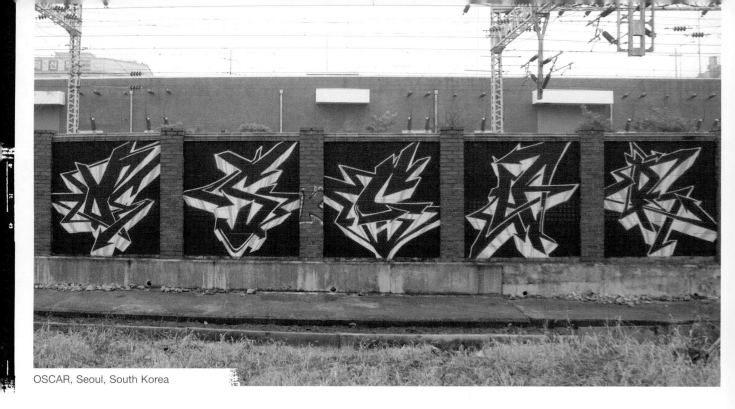

OSCAR, Seoul, South Korea

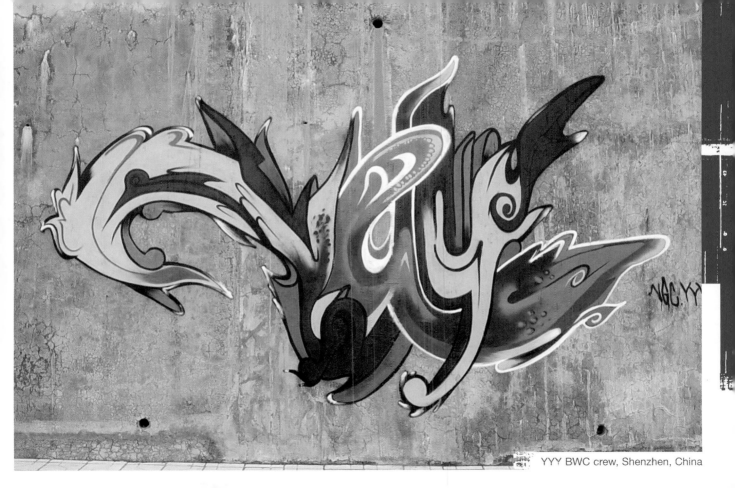

YYY BWC crew, Shenzhen, China

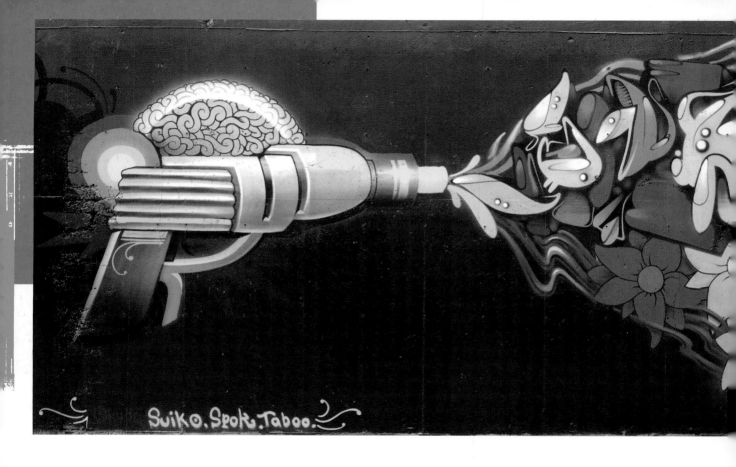

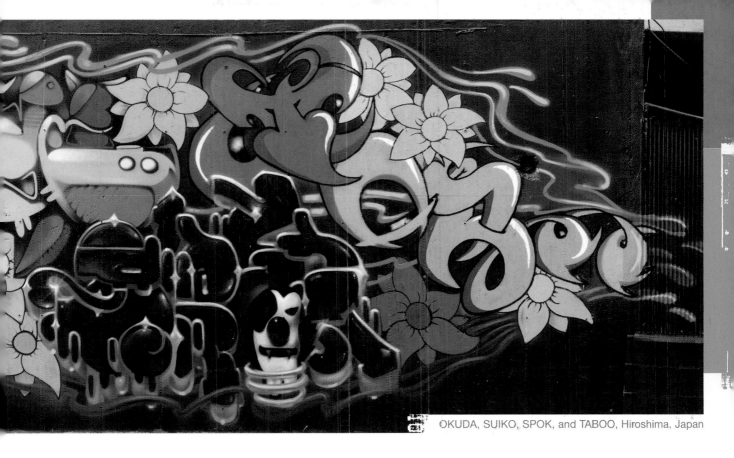

OKUDA, SUIKO, SPOK, and TABOO, Hiroshima, Japan

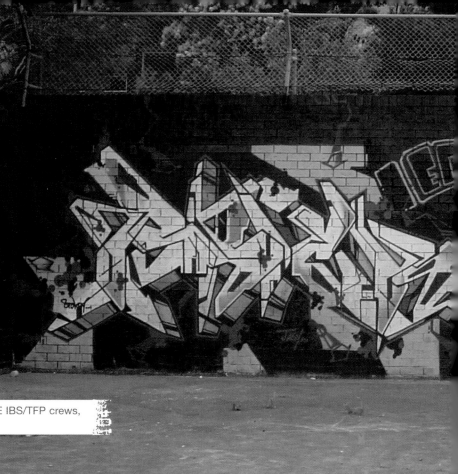

BRICK and ATOME IBS/TFP crews,
Sydney, Australia

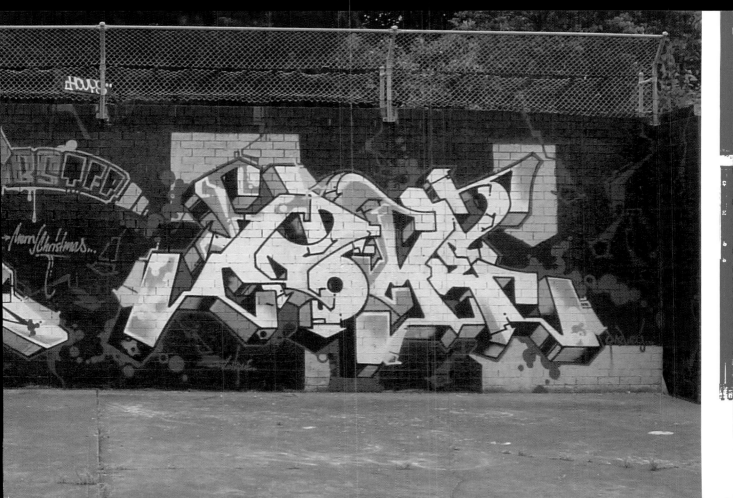

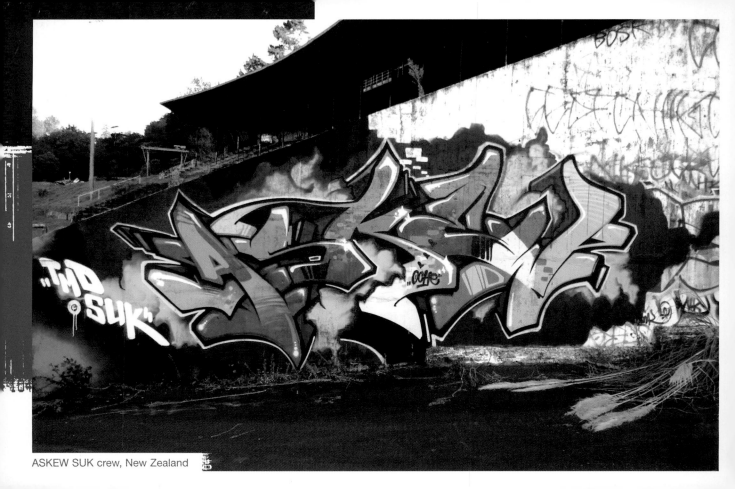

ASKEW SUK crew, New Zealand

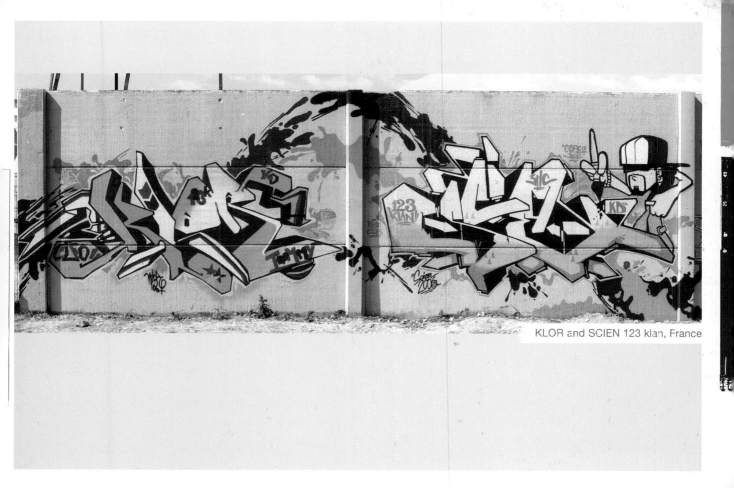

KLOR and SCIEN 123 klan, France

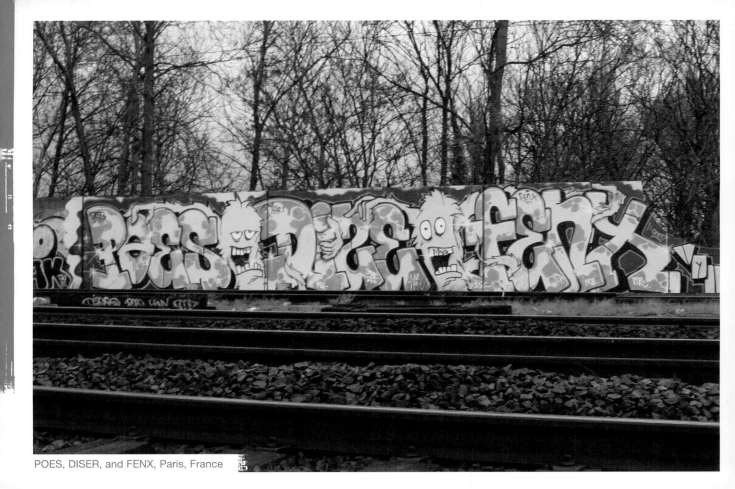

POES, DISER, and FENX, Paris, France

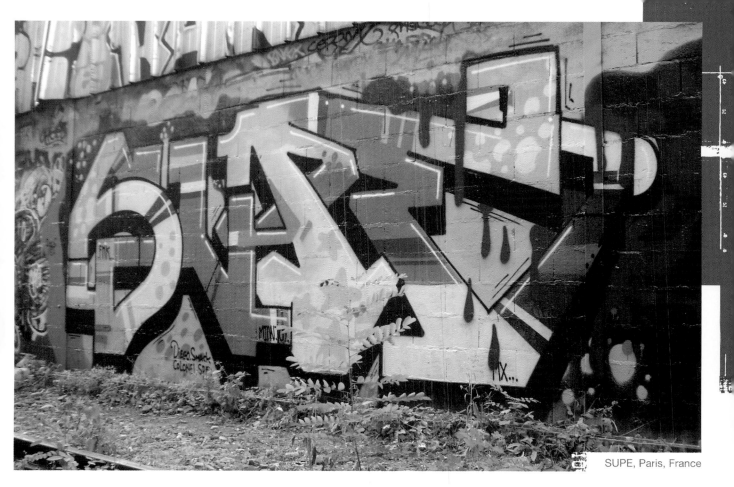

SUPE, Paris, France

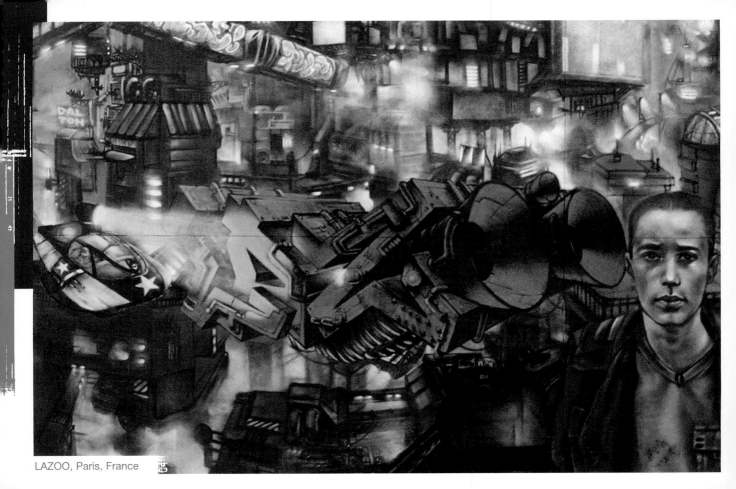

LAZOO, Paris, France

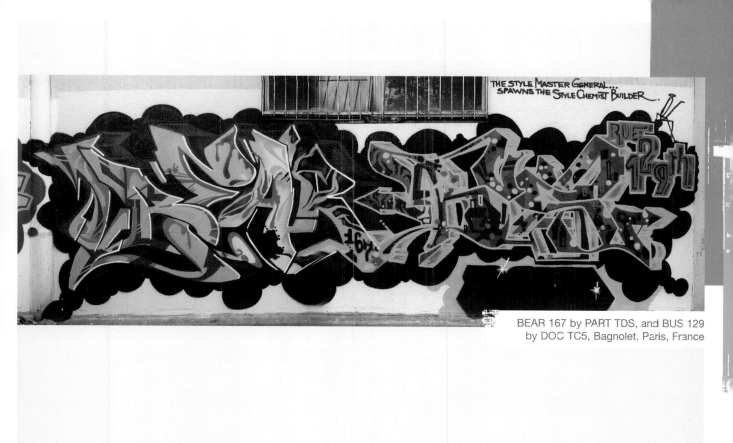

THE STYLE MASTER GENERAL...
SPAWNS THE STYLE CHEMIST BUILDER.

BEAR 167 by PART TDS, and BUS 129
by DOC TC5, Bagnolet, Paris, France

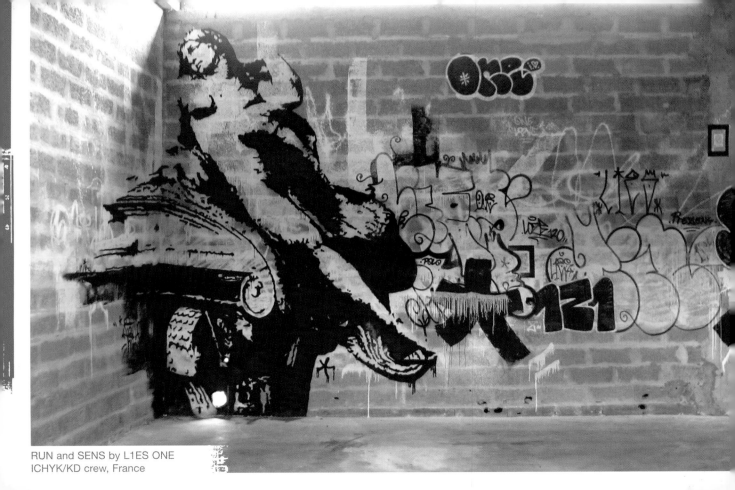

RUN and SENS by L1ES ONE
ICHYK/KD crew, France

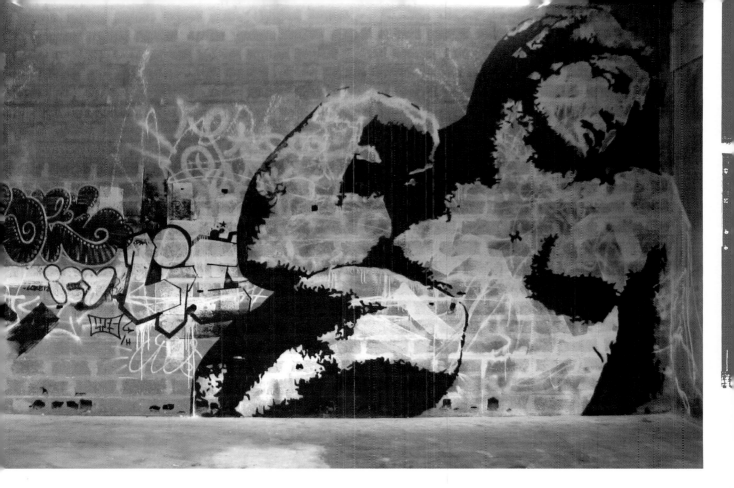

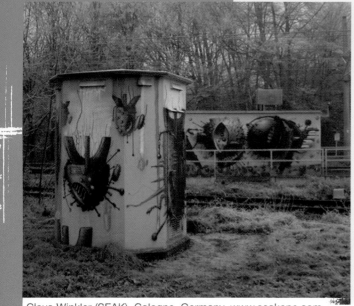

Claus Winkler (SEAK), Cologne, Germany. www.seakone.com

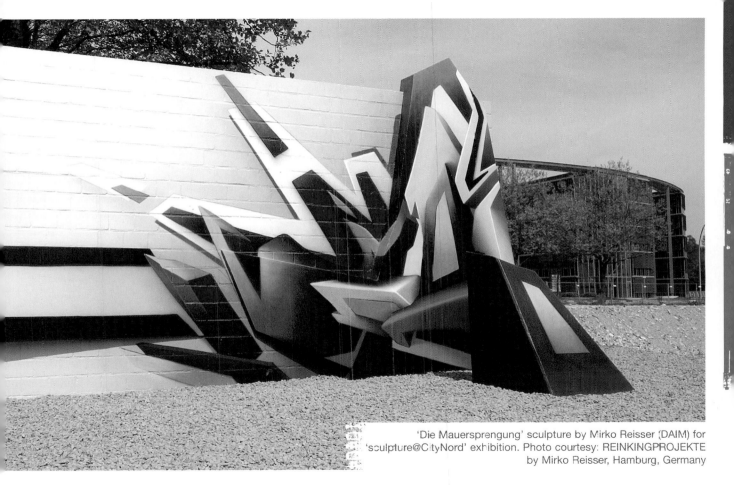

'Die Mauersprengung' sculpture by Mirko Reisser (DAIM) for 'sculpture@CityNord' exhibition. Photo courtesy: REINKINGPROJEKTE by Mirko Reisser, Hamburg, Germany

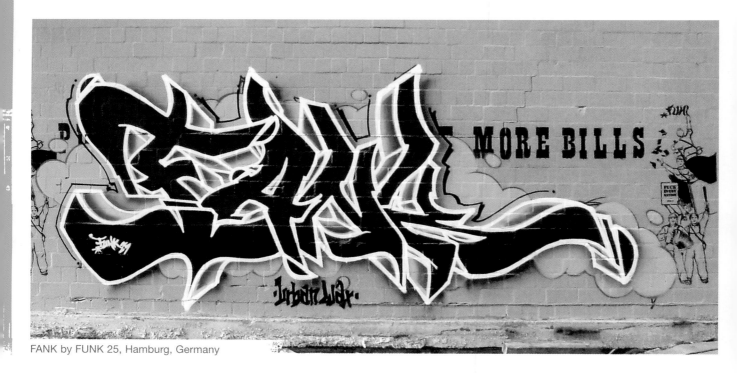

FANK by FUNK 25, Hamburg, Germany

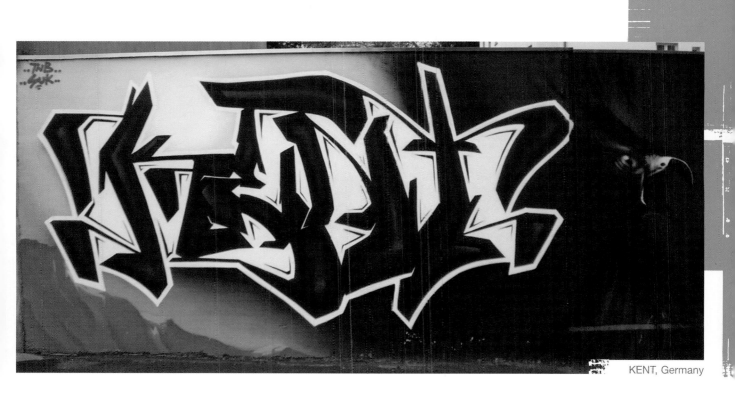

KENT, Germany

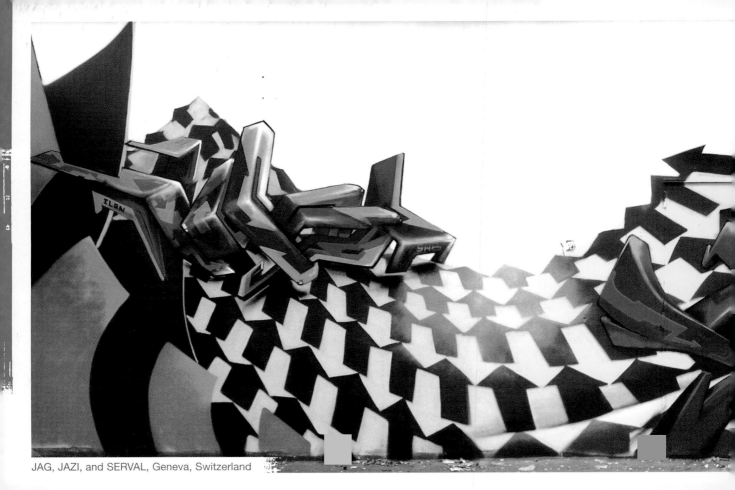

JAG, JAZI, and SERVAL, Geneva, Switzerland

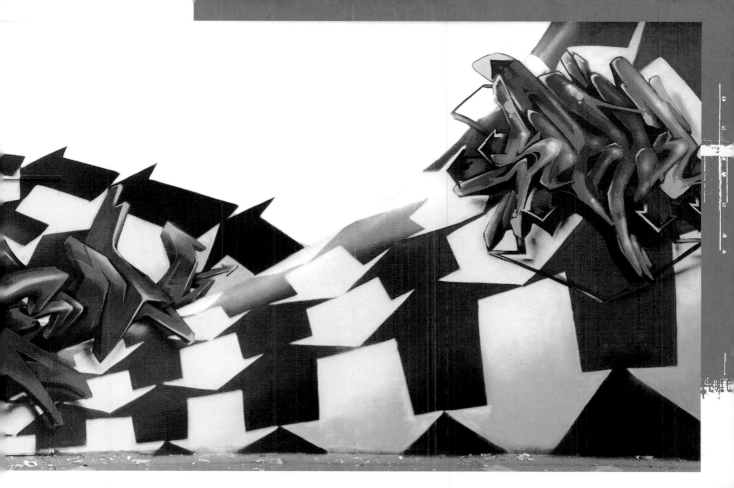

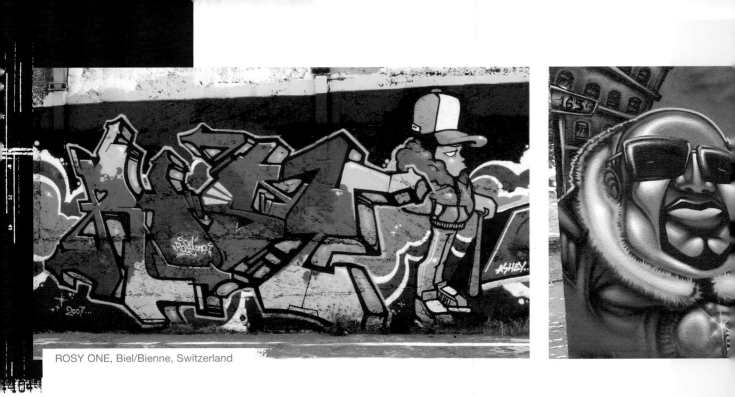

ROSY ONE, Biel/Bienne, Switzerland

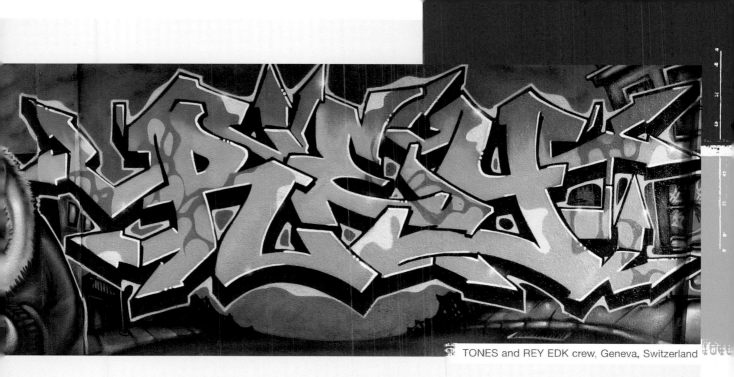

TONES and REY EDK crew, Geneva, Switzerland

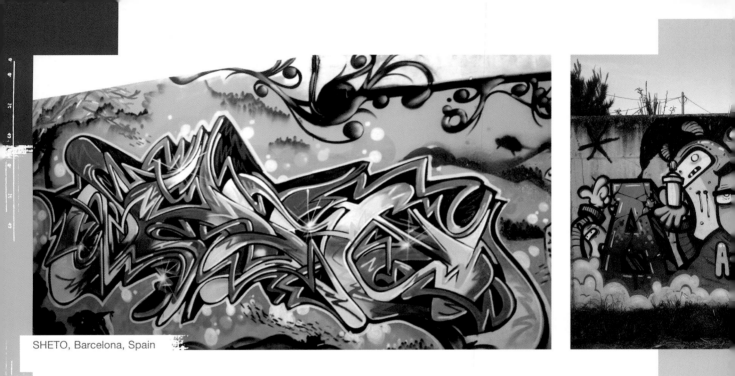

SHETO, Barcelona, Spain

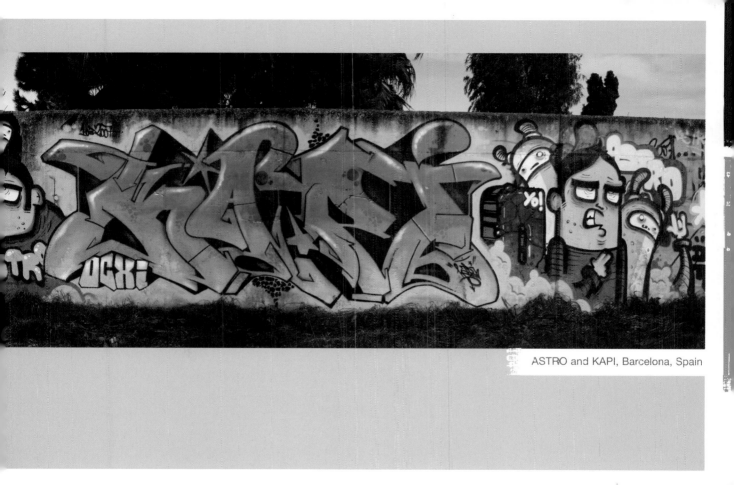

ASTRO and KAPI, Barcelona, Spain

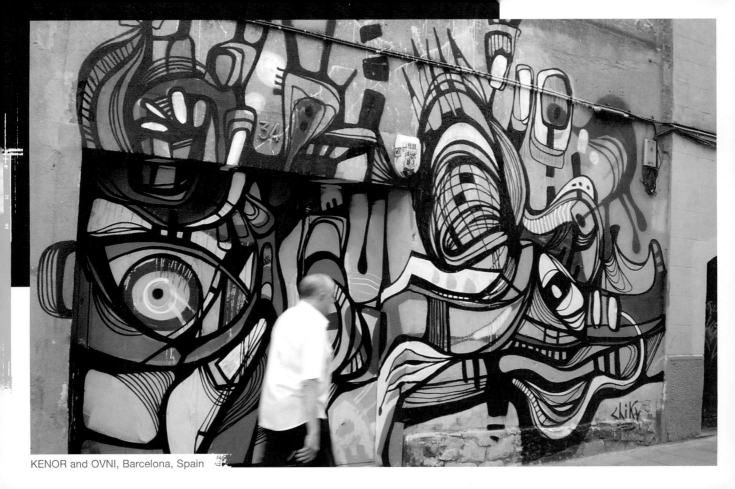

KENOR and OVNI, Barcelona, Spain

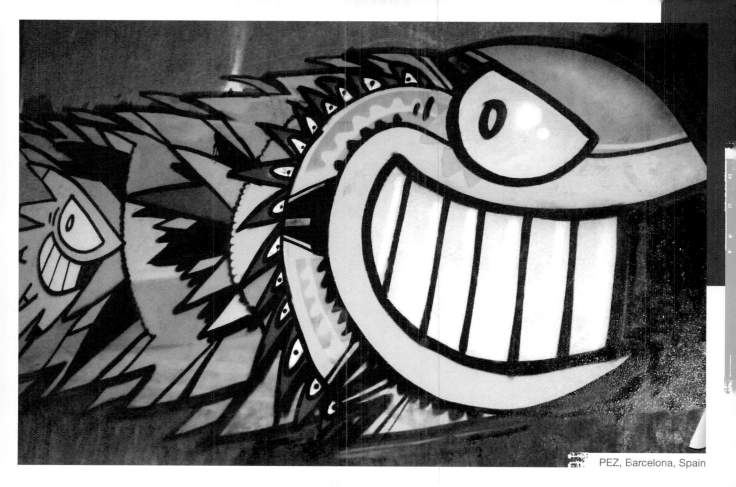

PEZ, Barcelona, Spain

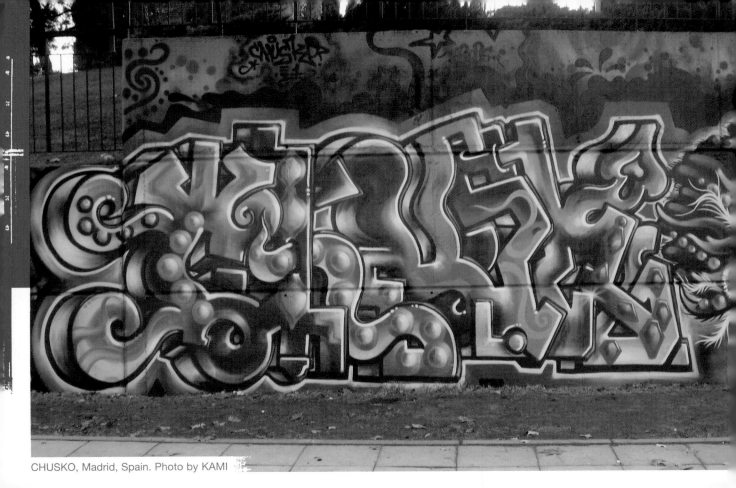

CHUSKO, Madrid, Spain. Photo by KAMI

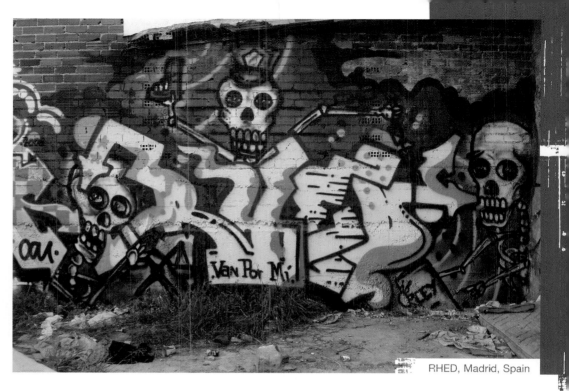

RHED, Madrid, Spain

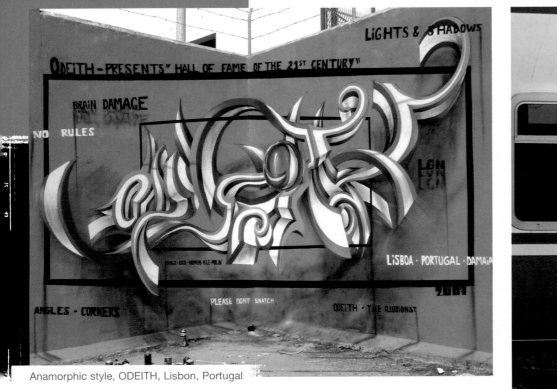

Anamorphic style, ODEITH, Lisbon, Portugal

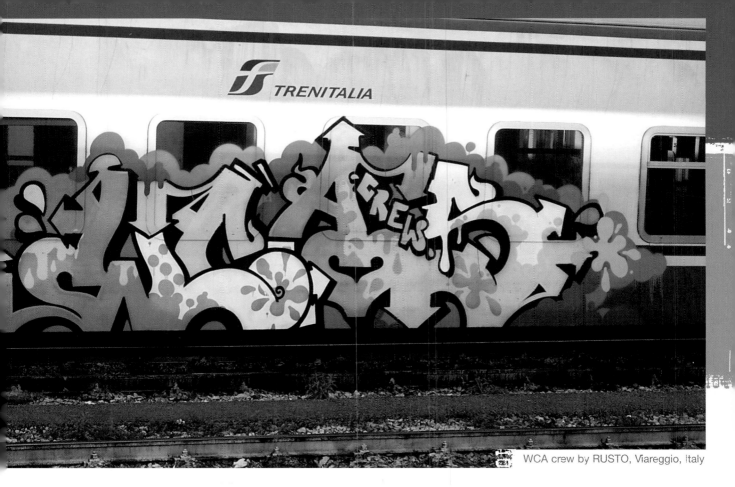

WCA crew by RUSTO, Viareggio, Italy

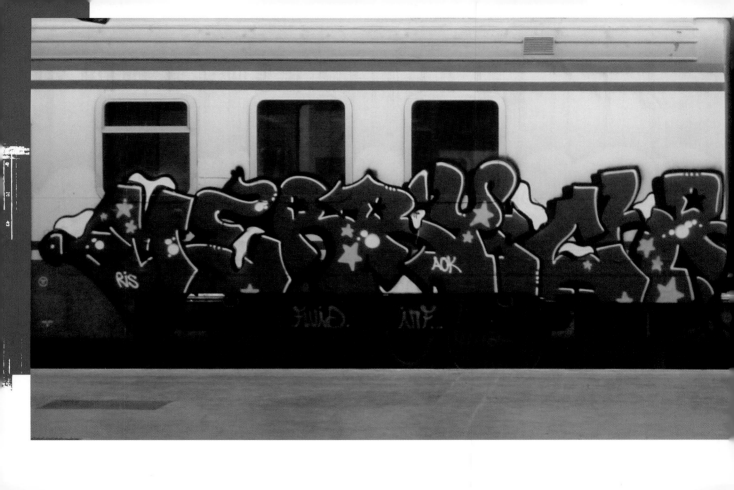

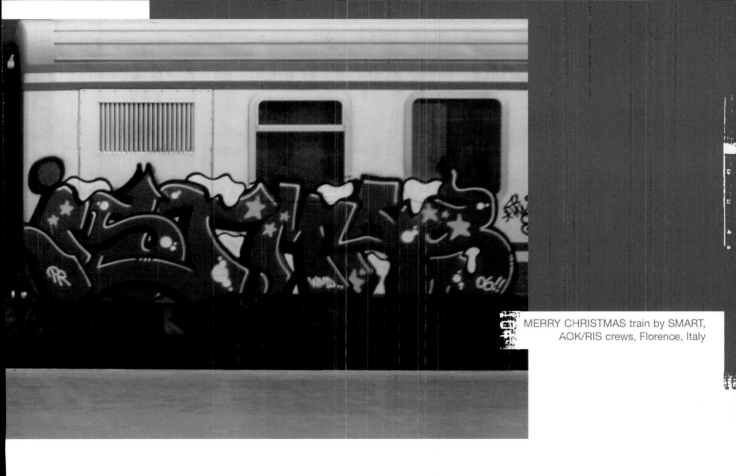

MERRY CHRISTMAS train by SMART,
AOK/RIS crews, Florence, Italy

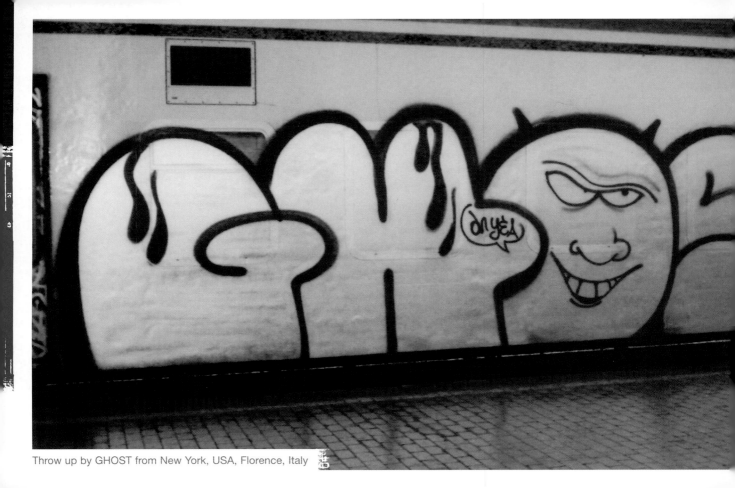

Throw up by GHOST from New York, USA, Florence, Italy

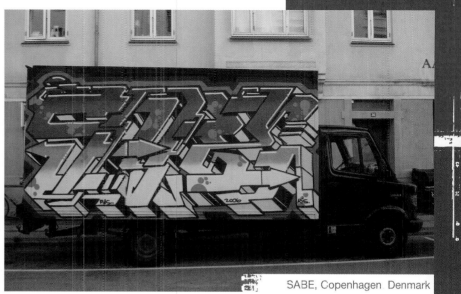

SABE, Copenhagen Denmark

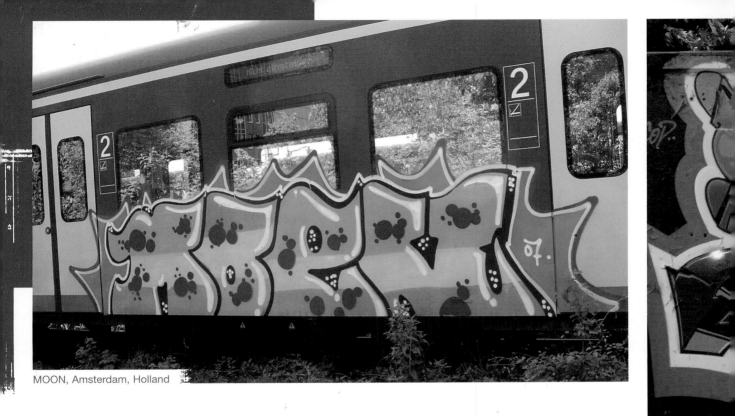

MOON, Amsterdam, Holland

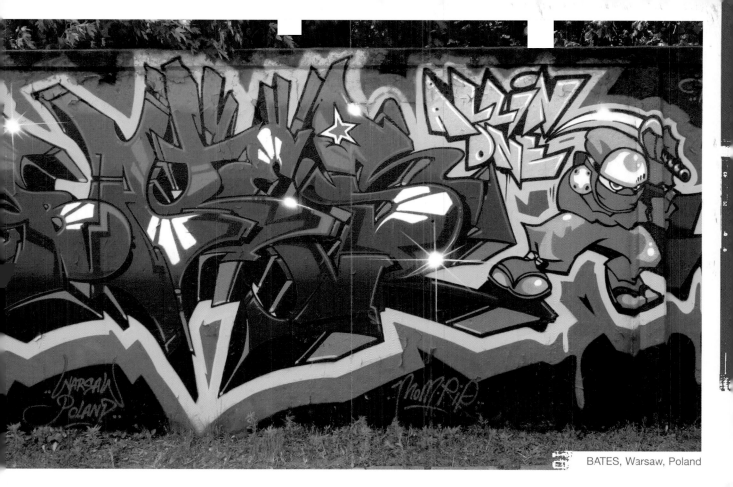

BATES, Warsaw, Poland

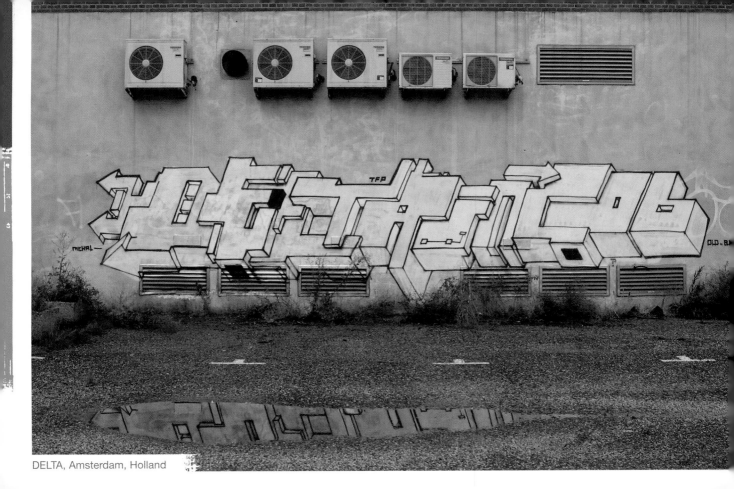

DELTA, Amsterdam, Holland

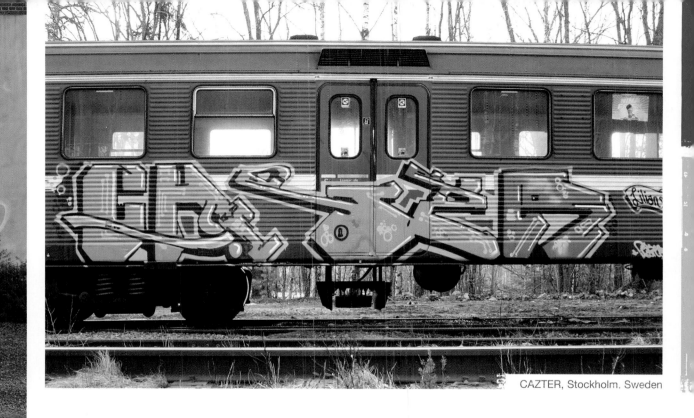

CAZTER, Stockholm, Sweden

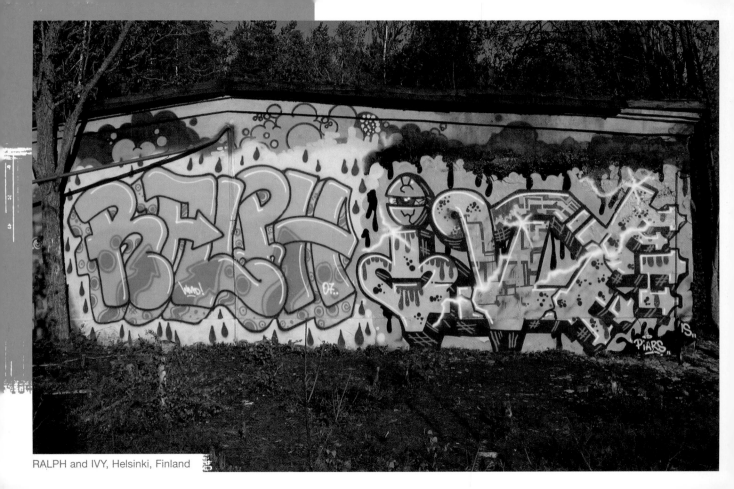

RALPH and IVY, Helsinki, Finland

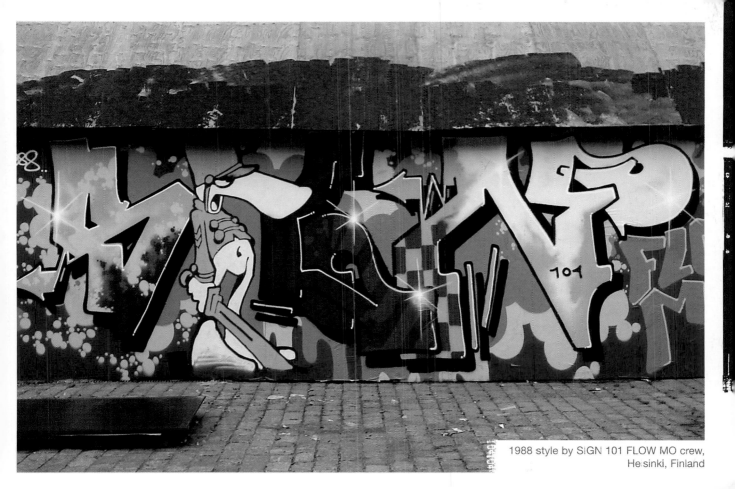

1988 style by SIGN 101 FLOW MO crew,
He sinki, Finland

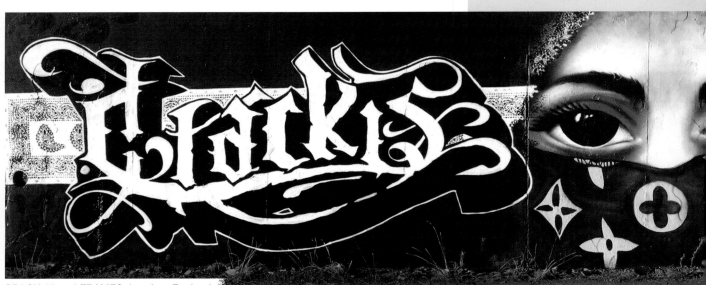

CRACK 15 and FRAMES, London, England

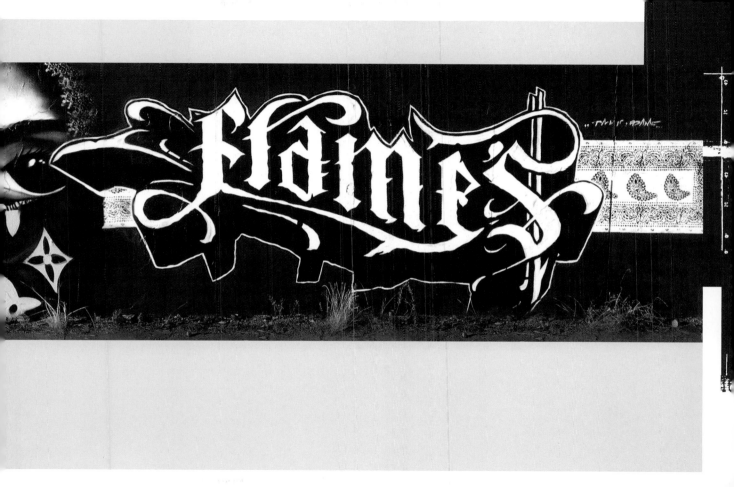

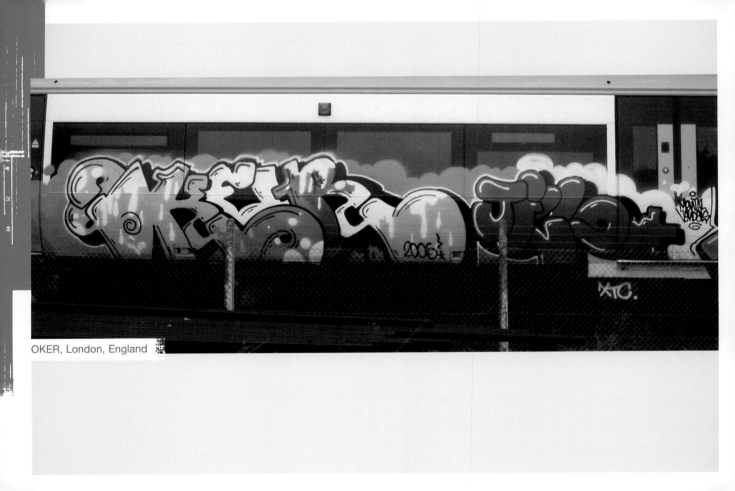

OKER, London, England

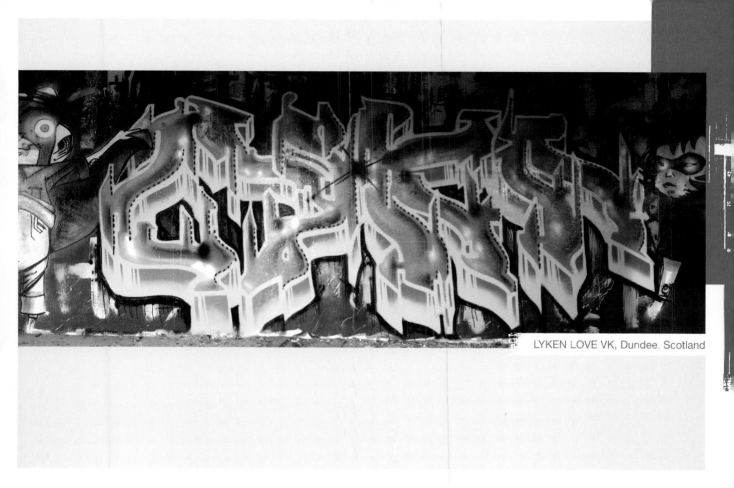

LYKEN LOVE VK, Dundee, Scotland

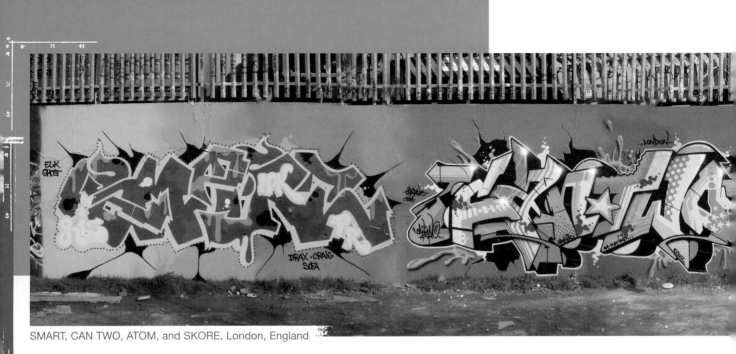

SMART, CAN TWO, ATOM, and SKORE, London, England

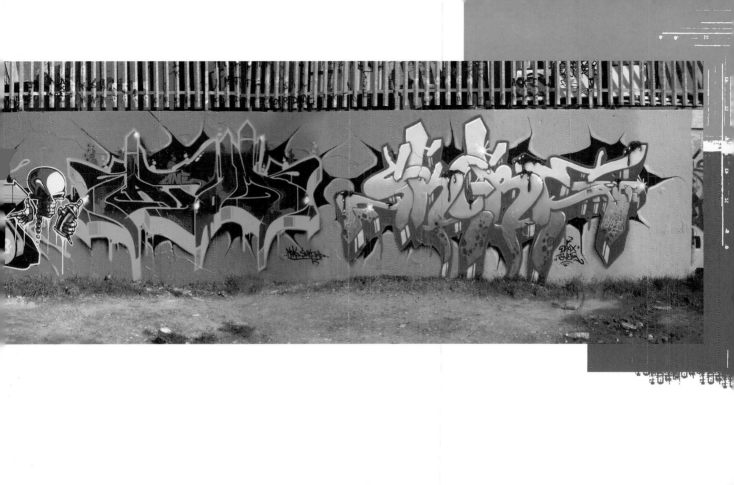

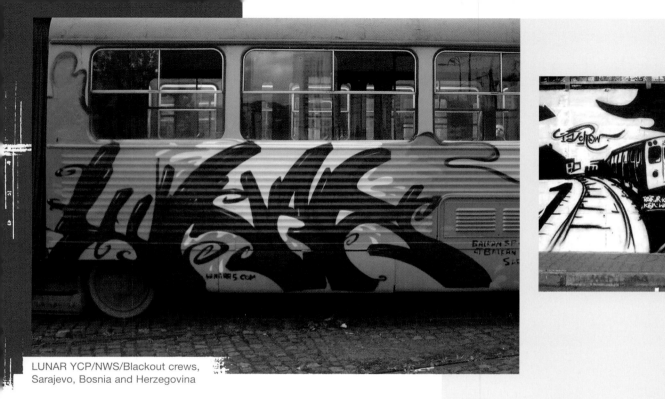

LUNAR YCP/NWS/Blackout crews,
Sarajevo, Bosnia and Herzegovina

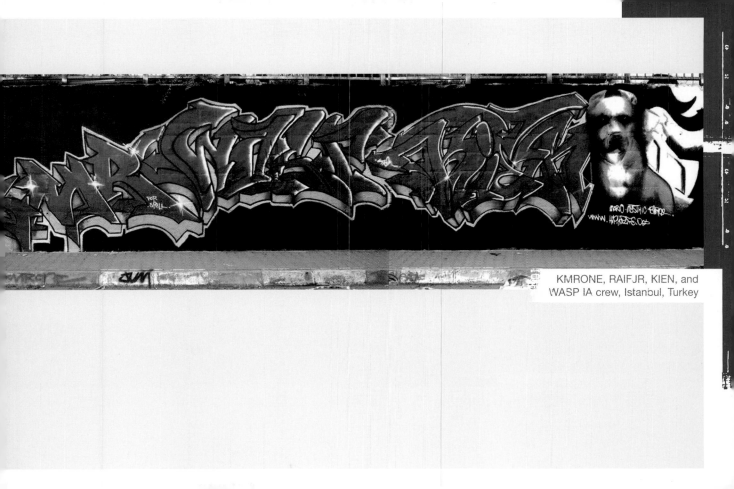

KMRONE, RAIFJR, KIEN, and
WASP IA crew, Istanbul, Turkey

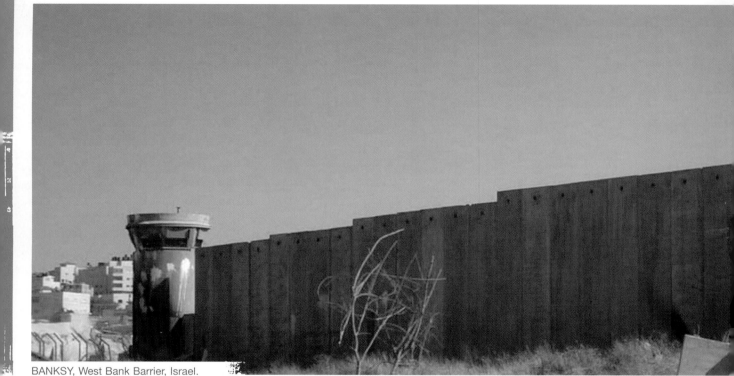

BANKSY, West Bank Barrier, Israel.
Photo from banksy.co.uk

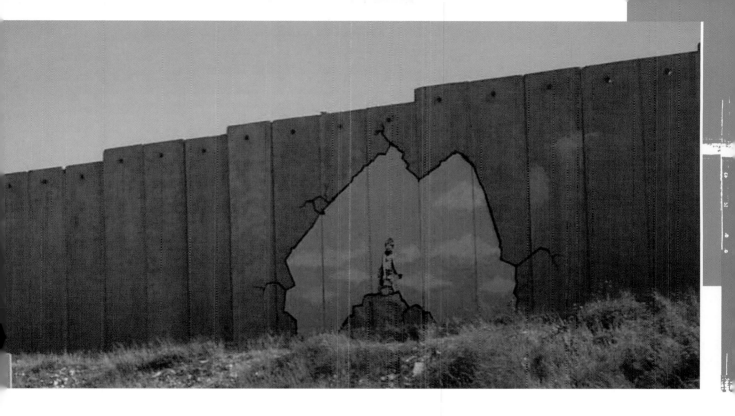

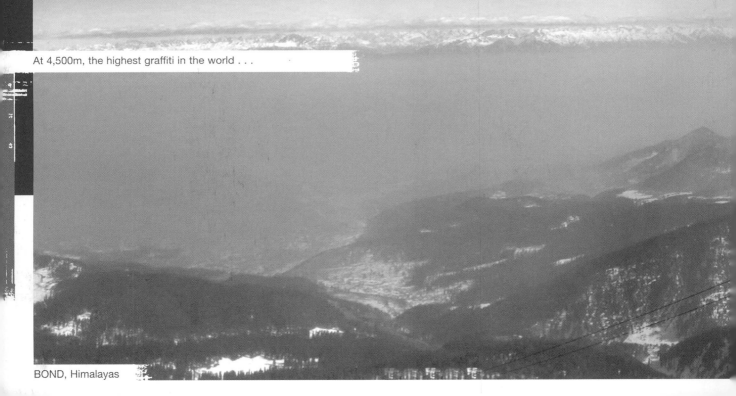

At 4,500m, the highest graffiti in the world . . .

BOND, Himalayas

KET started his career at the age of fifteen, when he began taking photographs of the striking subway trains in Brooklyn. Since then, his pictures have graced the pages of many newspapers and magazines, including *Rolling Stone*, *The New York Times Magazine*, *The* (London) *Sunday Telegraph*, *The Source*, and *Stress*.

At seventeen, KET was no longer content just to document graffiti – he wanted to create it as well. Once he perfected his tag, he quickly became a well-known graffiti writer both on the New York City subway lines and internationally. His painting has taken him around the world, where he has exhibited in major cities including Munich, Zurich, Paris, Stockholm, and Copenhagen.

Today, KET is a writer, lecturer, graffiti historian, producer, publisher, and painter. He is the proud father of two kids and lives in Brooklyn, New York. Currently, he is being prosecuted in New York City for allegedly writing on subway trains and, if convicted, faces many years in prison and huge financial penalties.

Find out more at www.supportket.org.

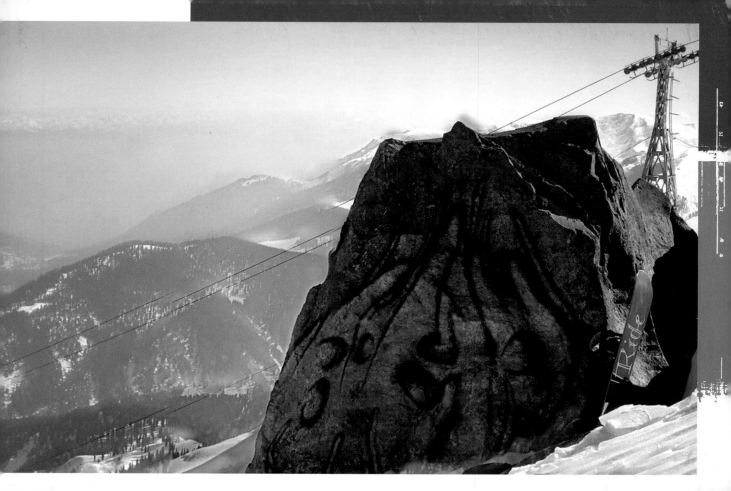

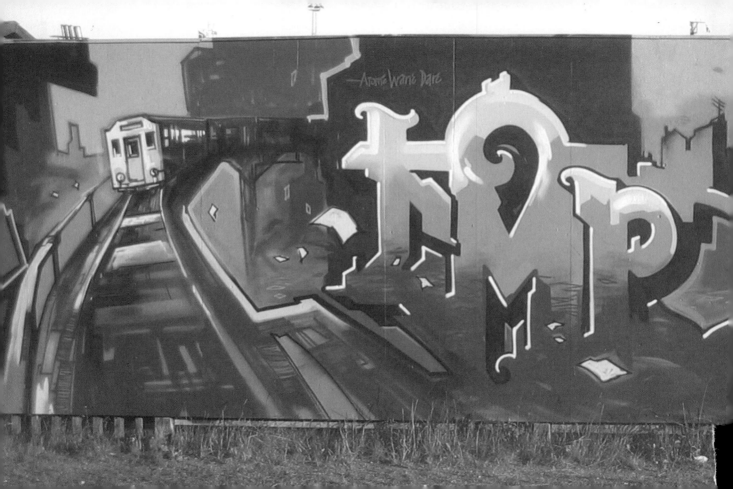